LEARN TO PAINT
LANDSCAPES
ALWYN CRAWSHAW *FRSA*

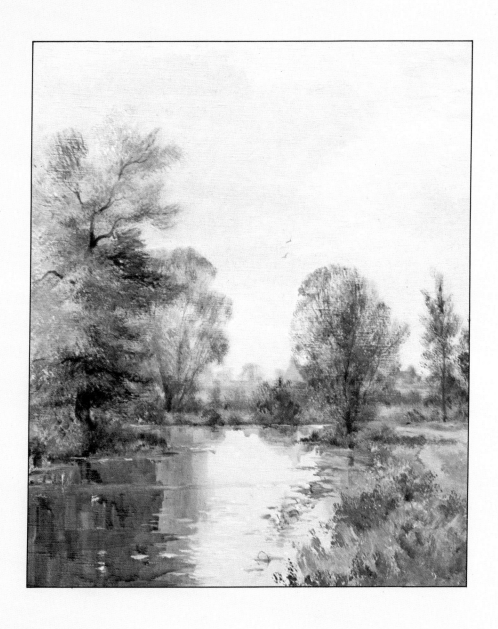

COLLINS

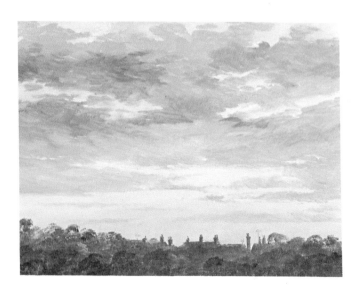

First published 1981
Reprinted 1981, 1982 (twice), 1985
William Collins Sons & Co., Ltd
London · Glasgow · Sydney
Auckland · Toronto · Johannesburg

© Alwyn Crawshaw 1981

Designed and edited by Youé and Spooner Limited
Filmset by Tradespools Limited
Photography by Michael Petts

ISBN 0 00 411873 1

Printed in Italy
by New Interlitho, Milan

CONTENTS

PORTRAIT OF AN ARTIST
ALWYN CRAWSHAW *FRSA*

Alwyn Crawshaw was born in 1934 at Mirfield, Yorkshire: he now lives in Surrey. During his earlier years, he studied the many facets of watercolour and oil painting and, more recently, acrylic and pastel painting. Now a successful painter, author and lecturer, his work has brought him recognition as one of the leading authorities in his field. This is his third book in Collins' *Learn to Paint* series. His first two books in the series covered the techniques of painting with watercolour and acrylic colours. He is included in *Who's Who in Art* and has been selected to appear in the fifth edition of the Marquis *Who's Who in the World*.

Crawshaw paints what he terms realistic subjects and these include many English landscape scenes which are frequently the subject of favourable articles and reviews by the critics. On numerous occasions these paintings have been compared with the works of John Constable, the best known of all the English landscape artists. In most of Crawshaw's landscapes there can be found a distinctive 'trade mark' – usually elm trees or working horses.

The widespread popularity of Alwyn Crawshaw's work developed after his painting *Wet and Windy* had been included among the top ten prints chosen by the members of the Fine Art Trade Guild in 1975. Fine art prints of this well-known painting are still very much in demand throughout the world. Another now famous painting was completed during Queen Elizabeth's Jubilee Year in 1977, when Crawshaw felt that he would like to record a particular aspect of the heritage of Britain symbolized by the celebrations of that year. After lengthy and painstaking research and hours spent working at the location, Crawshaw completed a large canvas entitled *The Silver Jubilee Fleet Review 1977*. Crawshaw has been a guest on BBC radio where he discussed his techniques when using acrylic colours as a painting medium. He demonstrates these techniques to members of many art societies throughout the country.

Many of Crawshaw's paintings are dispersed throughout the world. They are sold in art galleries in the main centres of the United Kingdom, France, Germany, North an

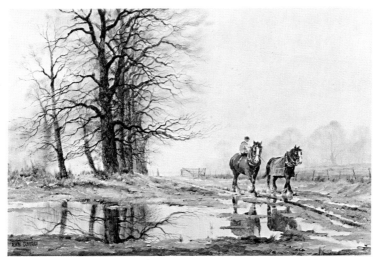

Gathering Mist, 61 × 91 cm (24 × 36 in). Fine art print, from an original acrylic painting by the author, illustrated by kind permission of Felix Rosenstiel's widow and son

South America, Australia and Scandinavia. Some of his works have also been exhibited in Russia and in Eastern Europe, particularly Poland, Hungary and Romania.

Among some of the most important one-man exhibitions of Crawshaw's work are his four shows in the art gallery at Harrods, the famous department store in Knightsbridge, London. He has also held a one-man exhibition at Chester, which was opened by the Duchess of Westminster who now has a Crawshaw painting in her private collection.

One-man shows of his work frequently draw an enthusiastic audience, no doubt because his paintings are popular with both public and critics alike. There is a feeling of reality about them, an atmosphere which at times succeeds in transmitting to the onlooker a faint memory, as if one had been there before. Whatever it is, and no matter the season of the year, this feeling is usually experienced wherever Crawshaw's paintings are on view.

Alwyn Crawshaw is married and he and his wife have three children, two teenage daughters and a younger son. At weekends or holidays a sketching day will frequently turn into a family day out, or, as Alwyn's wife, June, comments, a family day out will turn into a sketching day.

According to Alwyn Crawshaw, there are two attributes necessary for success as an artist: dedication and a sense of humour. The need for the first is self-evident; the second 'helps you out of many a crisis'. In addition, Crawshaw acknowledges the unfailing loyalty of his wife and family.

Horse and Snow, 51 × 76 cm (20 × 30 in). Acrylic colour, private collection

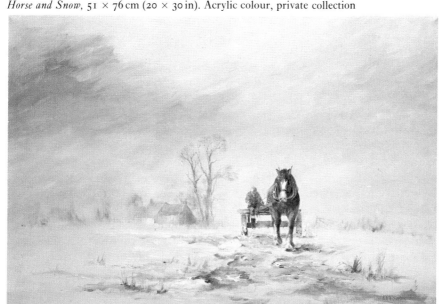

PAINTING LANDSCAPES

Landscape as a subject for painting is never ending. There is always something to see and paint. You could stand in the countryside on the same spot and from each of the four compass points see a different picture. Now add to that a sunrise, sunset, day time, night time, a sunny day, a windy day, a rainy day, a misty day and so on. Then add the four seasons of the year to the permutation. You can see that from just one viewpoint you could paint dozens of different pictures during the year.

Not only are there always subjects for the landscape painter to paint, but there is also the call of the 'great outdoors'. At certain times of the year we all have the feeling of wanting to get outside. We have the urge to get close to nature: to see the vast landscape in front of us with windswept clouds, or the tree fallen half across an old car track that has long since had its last horse and cart rumbling down its rutted surface.

All our senses, not just our visual sense, are with us all the time we are out. The sense of touch allows us to feel the wind, the warmth of the sun or the sting of nettles. Our sense of hearing also plays a big part in enjoying or 'seeing' the countryside: the birds singing, running water, wind blowing through trees, and so on. But above all, apart from seeing the countryside, the sense of smell gives m the most inspiration for painting landscape: the smell of long, sweet summer grass; the dank smell of wet autumn

You can work out-of-doors in any medium, and you do not necessarily need a large amount of equipment. Here, I am working in acrylic colour (left), sketching in pencil (below) and painting in pastel colour (below right)

eaves; the smell of a dusty road after a quick summer shower of rain.

It is not hard to understand why so many artists over the centuries have painted landscape. The artist doesn't have much chance of avoiding 'having a go' at landscape painting; not with enough different subjects to last a lifetime; all the different times of the day to choose from; the ever-changing moods of the four seasons; and his senses of sight, touch, hearing and smell being stimulated.

When you are out painting, your senses play a very important part in helping you with your work. Your visual sense will naturally give you the picture, and touch, hearing and smell will help you to keep the mood or atmosphere of

the painting. For example, if you can feel the warmth of the sun, you will be constantly reminded that you are painting a warm picture. If you can hear birds singing, then you are reminded that the landscape is alive and tranquil and you are not at a football match! Finally, the overall smell of a warm summer's day will complete the total awareness of what you are painting. If all this sounds a little too contrived, try to imagine yourself out-of-doors painting a view that you can see, but being unable to feel the sun, hear the birds, or smell the summer grass. You would paint a picture totally without feeling or atmosphere, and a landscape painting without these is a dead picture.

To paint landscape indoors from outdoor sketches is a

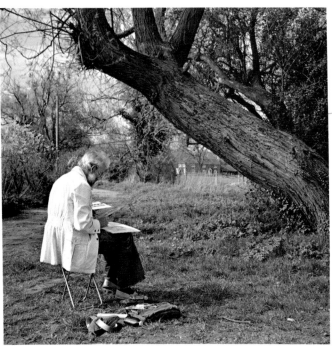

Watercolour is an ideal medium for working out-of-doors, and is probably the most convenient medium for the beginner

Oil colour is a traditional medium for outdoor painting, and everyone can enjoy working with it

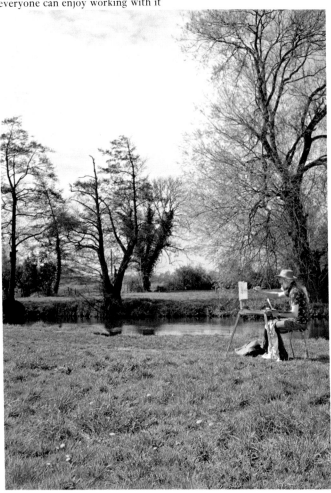

very natural way of painting. Most of the old masters worked outside on smaller studies and then used the sketch for information and inspiration for larger indoor paintings. One great advantage of painting indoors is that it gives you more time to consider the progress of your painting and to change parts of it if you feel it necessary.

While I have been working on this book one thing has worried me, and that is the use of the words 'sketch' and 'sketching'. They are both very commonly used in painting: 'I just did a quick sketch'; 'I am going out sketching'; 'I like that little sketch', and so on. These are phrases we have all heard and are often used among artists. The word 'sketch' can mean so much and yet so little. Is it a rough drawing or is it a finished picture? It seems to me that we should define sketch from the landscape artist's point of view. I believe there are four distinct and very practical types of sketch:

Enjoyment sketch A drawing or painting worked on location, done simply to enjoy the experience.

Information sketch A drawing or painting done for the sole purpose of collecting information (detail) which can be used later at home.

Atmosphere sketch A drawing or painting worked for the sole purpose of getting atmosphere and mood into the finished result. It can then be used at home for atmosphere and mood information, or as an inspiration sketch for an indoor landscape painting.

Specific sketch A drawing or painting done of a *specific place* for the purpose of gathering as much information (detail and atmosphere) as possible, and which conveys the mood or atmosphere of the occasion. The sketch is used as the basis for a finished studio painting. The 'specific sketch' is really a combination of the information and atmosphere sketches, but the real difference is that the object is to go to a *specific place* to record what you see and feel, and then to use all this information for a larger studio painting.

All sketches, whether they are drawings or paintings, can be used as 'finished' works; in fact, some artists' sketches are preferred to their finished paintings. We will cover sketching in more depth later in the book. **Fig. 1** shows an enjoyment pencil sketch drawn from a train window (while travelling at 70 m.p.h.) in only 30 seconds. You can see an atmosphere sketch and a specific sketch on p. 32.

The real master for all landscape artists is Mother Nature. You must never forget this. Try as much as possible to go out and paint the countryside. Observe all you can; even when you are sitting as a passenger in a car or train look at what you see with the object of painting it. When I was at art school I was taught to observe and translate what I saw into a painting (in my mind!), and I am still doing this. I could be walking outside and talking with my family about anything other than painting, when I stop and say to everyone with tremendous excitement, 'Look at that, isn't it fantastic? It would make a perfect

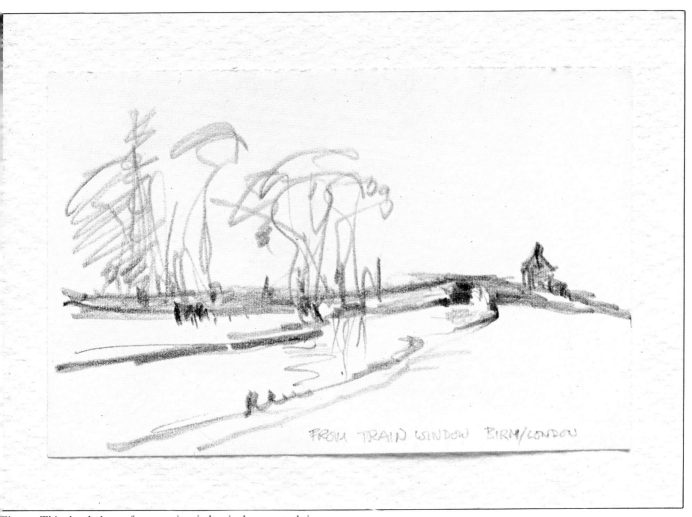

Fig. 1 This sketch drawn from a train window is shown actual size,
so you can see the small scale on which you can work

watercolour', or acrylic painting, or whatever medium
suited the scene.

Whenever you go out-of-doors carry a small sketch-book
with you. If you have a little time on your hands, get out
the sketch-book and set about drawing. Try not to miss an
opportunity. If you are aware of wanting to sketch, you will
find plenty of opportunities coming your way, and if they
don't, put a little pressure on yourself and make some:
'If there's a will – there's a sketch'!

I wrote this book to teach you and to help you to *paint
landscapes*, and to do this I decided not to work in just one
medium, but to use watercolour, oil colour, acrylic colour
and pastel colour. This will help me to show you the depth
and variety of expression in landscape painting. If you
want to learn more about these four media, there are four
books in this series which are very informative and cover
each medium in great detail. They are: *Learn to paint with
Acrylic Colours* and *Learn to paint with Watercolours* by
Alwyn Crawshaw; *Learn to paint with Oils* by Peter John
Garrard, and *Learn to paint with Pastels* by John Blockley.

In the following lessons and exercises there is no under-
lying reason why a painting is done in one medium or
another. If there is any specific reason, it is that the subject
matter was more suited to that particular medium.

When you are out painting try not to get too obsessed
with your work or you will miss the joy of being outside
and painting. Whatever you do, make your painting enjoy-
able. Naturally, there are going to be times when nothing
goes right and you will blame everything from your
paintbrush to the weather. This happens to all of us, but
remember that whatever you put down on paper when
working direct from nature is spontaneous and something
will always be learned, no matter how brief the encounter.
Never throw away a poor sketch or painting; every line
tells a story. Even if it says: 'Don't do it this way again!',
it will serve as a constant reminder!

I decided to paint a picture of the 200th running of the
Derby at Epsom, Surrey. This 'day out sketching', to put
it mildly, gives me the perfect opportunity to talk about
my experience of going out to do a 'specific sketch'. It
clearly shows the difference between the uses of the word

sketch. The Derby sketches were completely planned and premeditated, in contrast to the quick pencil sketch illustrated in **fig. 1** on p. 9.

I had never been to a horse-race meeting before and my initiation was to be at the 200th running of the most well-known horse race in the world, the Derby at Epsom. The national media were suggesting that there could be up to half a million people attending. As all paintings must be planned, this day had to be – and carefully. It all started on the Saturday before the race. The Derby was the following Wednesday afternoon. A friend of mine said he would take me to the racecourse so that I could get familiar with it, and to decide if possible where I was going to paint from.

It was a pleasant and warm afternoon and it amazed me to see just how much was going on four days before the race. The fairground was in full swing, there were rows of caravans with gipsy fortune-tellers hovering, waiting for their next customer. I would have loved to have asked what the weather was going to be like for the race and my day of painting! But I didn't stay to find out; the important job in hand was to find the right spot for me to work from.

We walked through the tunnel under the track and out on the middle of the course, and then walked (I walked backwards) up the hill looking at the view. I stopped on two occasions and each time did a pencil sketch, 28 × 41 cm (11 × 16 in) of the stand area (information sketch). This was very important as this area would be partly obscured by people on the day. When we had finally walked to the top of 'the hill' I was in no doubt as to what I was going to paint. The view was vast; I was able to see miles into the distant countryside and yet get most of the finishing straight and stands into the picture. I had decided earlier that if I could get that type of view I would work the painting on a 76 × 152 cm (30 × 60 in) canvas. Now that my mind was made up, I sat down and worked on the pencil sketch in **fig. 2** and I was very excited about the prospects for the big day on Wednesday.

The race was to start at 3.25 p.m. but, because of the vast crowds of people expected, I decided to get there about 8 a.m. My 19-year-old daughter, Donna, was coming with me and she also was planning to do some sketching. The sketching equipment was checked the night before (too late once you were there) and we set off at 7 a.m. It is easy to say now in retrospect, but everything went according to plan. By 8.30 a.m. the car was parked on 'the hill' in exactly the spot I wanted and we were having hot fish and chips from a fairground booth for a second breakfast. We wandered about in amazement, looking at all the different stalls selling their wares, ranging from fish and chips and sweets to teddy bears, wall mirrors, brass ornaments and T-shirts. It was a big, open market full of character and life. All my senses were soaking in the atmosphere. I also had my camera and was gathering information with it all the time. Then it was time to get on with the actual sketching from my pre-arranged vantage point. In the finished painting on the opposite page, the market and a lot of the

The photograph I took of the scene

activity additional to the horse racing is to the left, down and behind the big marquees.

I finally got settled with my drawing board, paper and watercolour paints and just sat and looked at the scene for half an hour (to get accustomed to it) and then started. I drew the picture first with an HB pencil, and then went into a full-blooded watercolour. I worked the watercolour sketch 37 × 53 cm (14½ × 21 in). As I worked, the scene was growing rapidly in front of me as more and more cars and coaches converged on the race meeting. I worked on the main parts of the painting for a solid two hours without a break, then added more work to it over the next hour and a half. Because of the sketching I had done on the previous Saturday I did not feel strange when painting; in fact, I felt as though I had been at the race before – this helped the drawing to flow and much of my concentration could be applied to colour and atmosphere. The finished watercolour sketch is reproduced in **fig. 3**.

We finally got home around 8 p.m. It was a very exhilarating day and not until I sat down at home that evening did I realize how exhausted I was. I had achieved everything that I had wanted, and I had enough information from my pencil sketches, watercolour, memory and photographs to paint in the studio the picture of the Derby. I also painted a smaller one, 41 × 61 cm (16 × 24 in), of the horses approaching Tattenham Corner in the actual race.

This type of sketching out-of-doors is an extreme contrast to a normal 'afternoon in the country' outing, but it is worth organizing something like this as a special, perhaps once or twice a year, because it helps to create self-discipline and planning, which are both very important ingredients for making a landscape artist. Not only that, but if you approach it in the right way you will thoroughly enjoy it. Incidentally, I didn't back the winner!

Before you start to paint or rush out to find the nearest racecourse, I would like you to relax and to carry on reading this book. I will take you through stage by stage, working very simply to start with, and then progress to a more mature form of painting. When you do start the lessons

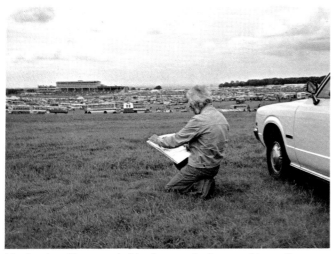

My daughter Donna took this photograph of me working at Epsom

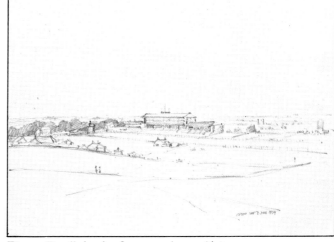

Fig. 2 Pencil sketch, 28 × 41 cm (11 × 16 in)

and exercises – enjoy them. If you find some parts difficult, don't become obsessed with the problem – go on a stage further and then come back; seeing the problem with a fresh eye will make it easier to solve.

Remember: *A good landscape painting or drawing is the end result of sympathetic and careful observation.*

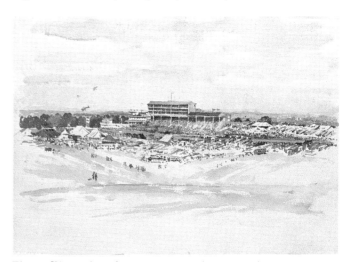

Fig. 3 Watercolour sketch, 37 × 53 cm (14½ × 21 in)

The 200th Epsom Derby Day, 76 × 152 cm (30 × 60 in). Acrylic colour, private collection

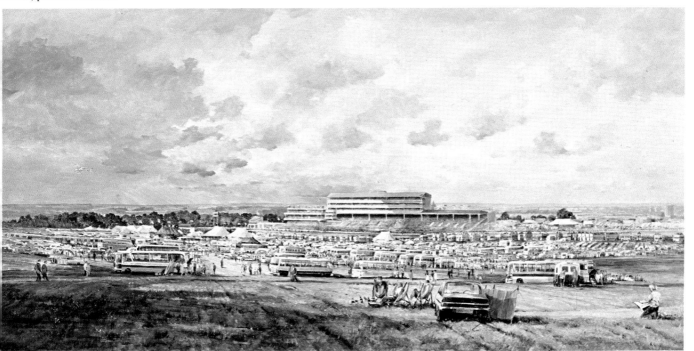

WHAT EQUIPMENT DO YOU NEED?

Equipment for painting landscape is virtually the same as for any other subject and you can have a room full of equipment, or just the right basic essentials. The choice is up to you. One word of warning: it is always best, for easier working and better painting results, to buy the best quality materials you can afford. The photograph opposite shows materials that can be used for acrylic, oil, pastel and watercolour painting, and there is a key below. On p. 15 I have illustrated materials that you can use to take out sketching, or to work at home. They are the basic requirements for each medium and they are the materials I have worked with throughout this book.

Colours

Watercolour You can buy watercolours in tubes, or in half or whole pans. I do not advise beginners to use tubes because it is difficult to control the amount of paint on the brush. You can buy pans individually or in boxed selections. The colours I have used are: Payne's Grey, Burnt Umber, Hooker's Green No. 1, French Ultramarine, Crimson Alizarin, Yellow Ochre, Coeruleum Blue, Burnt Sienna, Cadmium Red, Raw Umber, Raw Sienna, Cadmium Yellow Pale.

Acrylic colour There are several types of acrylic colour on the market: the two I use are Standard Formula and Flow Formula. Standard Formula has a consistency similar to oil colour and is ideal for palette knife work. Flow Formula flows – it is much better to use with a brush, and takes a little longer to dry than Standard Formula. I use Flow Formula as my basic paint. You can also buy Texture Paste to help to build up a heavy impasto. The colours I have used are: Coeruleum Blue, Bright Green, Burnt Umber, Raw Umber, Cadmium Yellow, Cadmium Red, Crimson, Ultramarine, Raw Sienna, White.

Oil colour The oil colours I have used are: Cobalt Blue, Cadmium Red, Cadmium Yellow, French Ultramarine, Viridian Green, Crimson Alizarin, Burnt Umber, Yellow Ochre, Titanium White.

Pastel colour There are over 50 different pastel colours, and each one is available in several tints, making over 200 pastels in all. Rowney pastels are graded from Tint 0 for the palest to Tint 8 for the darkest. The best way to start is to buy a box of 12 or 36 Artists' Soft Pastels for Landscape. I have used only the pastels in these two boxes for all the exercises. When you get used to the medium you can buy different tints, colours or refill pastels individually.

Brushes

I believe the most important 'tool' that an artist uses is his brush – or painting knife. The brush is the means by which

A CANVAS BOARD

B BRUSHES & BRUSH HOLDER

C PAINT RAG

D OIL PAINTING CASE
OIL COLOURS, GEL MEDIUM, TURPENTINE,
LINSEED OIL, BRUSHES

E OIL PAINTING PALETTE, DIPPERS,
PALETTE KNIFE, VARNISH, LIGHT DRYING OIL

F CANVAS, CHARCOAL

G ACRYLIC PRIMER, MEDIUMS, TEXTURE PASTE,
GEL RETARDER, COLOURS, STAYWET PALETTE

H BRUSH CASE

I WATERCOLOUR BOXES, SPONGE,
MAPPING PEN, SABLE BRUSHES

J DRAWING BOARD, PAPER, BLACK WATERPROOF INK,
WATERCOLOUR PAD, PENCILS

K KNEADABLE PUTTY RUBBER, MIXING PALETTE,
BLOTTING PAPER, WHITE DESIGNERS' GOUACHE

L FIXATIVE SPRAY

M BOX OF 36 LANDSCAPE PASTELS

N PASTEL PAPER & SKETCH-PAD,
SOFT DUSTING BRUSH, PASTELS

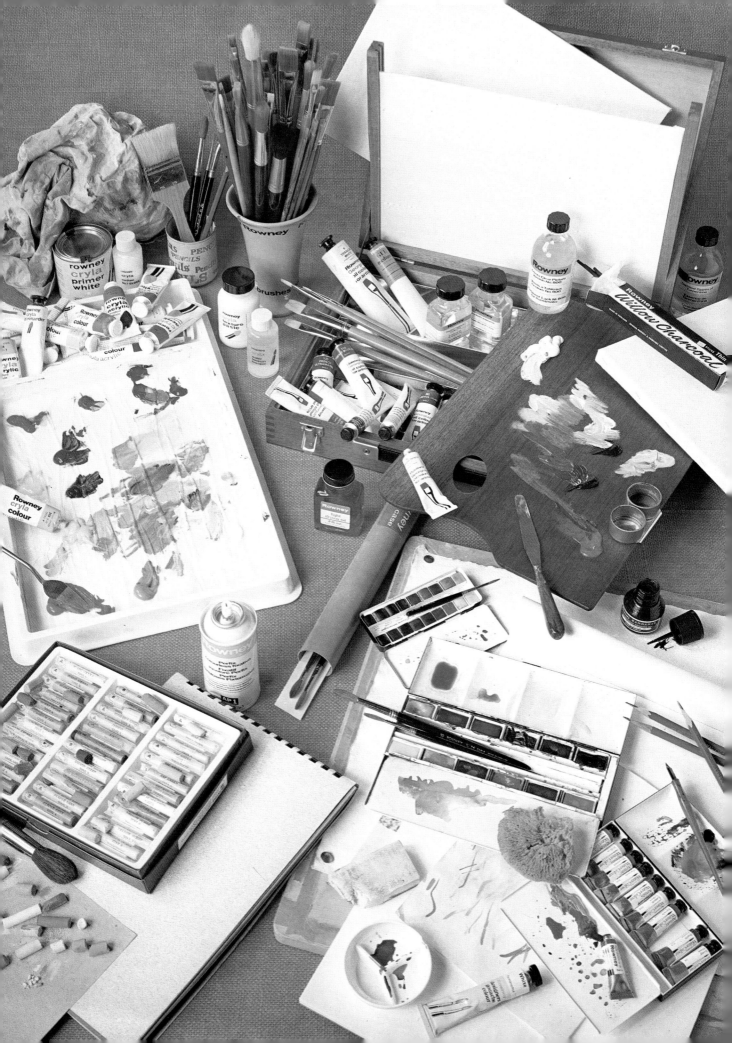

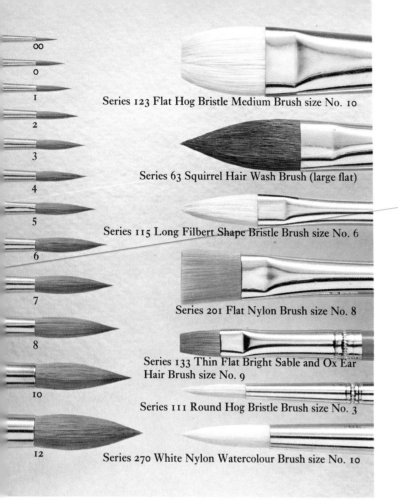

00
0
1
2
3
4
5
6
7
8
10
12

Series 123 Flat Hog Bristle Medium Brush size No. 10

Series 63 Squirrel Hair Wash Brush (large flat)

Series 115 Long Filbert Shape Bristle Brush size No. 6

Series 201 Flat Nylon Brush size No. 8

Series 133 Thin Flat Bright Sable and Ox Ear Hair Brush size No. 9

Series 111 Round Hog Bristle Brush size No. 3

Series 270 White Nylon Watercolour Brush size No. 10

Fig. 4

the painted effects are applied. If you want a particular effect, whether bold or delicate, it is your brush that will dictate the result. Therefore, I cannot stress too much the importance of buying the best brushes that you can afford. In the beginners' basic sketching sets listed below I have suggested what you need to start with (the series numbers refer to the Rowney catalogue and will help you to identify the different types of brush). In **fig. 4** there is a selection of brushes which shows the different shapes, types of 'hair' and sizes. They are all reproduced actual size. The brushes on the left are round sable brushes, from size No. 00 to size No. 12. Some brush series have additional sizes, i.e. Nos. 9, 11 and 14.

Always look after your brushes. This doesn't mean that you should keep them in a glass case but that you should work them and work them hard. A good brush can take a lot of hard work. If you look at my nylon 'tree brushes' on p. 48 you might think that I never look after brushes at all. But those brushes have a special use painting feathery branches on trees and have been cared for and looked after, having been used nearly every day for the past four or five years – that's a lot of hard work for any brush. If they had not been of the finest quality to start with, and if I had not looked after them, they would have been finished years ago.

Basic sketching sets
Watercolour (fig. 5) You can start with only two brushes: a size No. 10 round and a size No. 6 round. The quality

you get will depend on the price you pay, but they should be sable. You need a paint box to hold 12 whole pans of colour or 12 half pans (the one illustrated holds whole pans), HB and 2B pencils, a kneadable putty rubber (this type of rubber will not smudge), a drawing board with watercolour paper or a watercolour sketch-pad, blotting paper, a sponge and a water jar. Finally, I suggest you carry a tube of white paint with your equipment. I use Designers' Gouache.

Acrylic colour (fig. 6) I have used four nylon brushes for the exercises in this book (these are illustrated). They are Series 220, size No. 2, and Series 201, sizes Nos. 4, 6 and 12; and also a size No. 6 sable brush (round). For very thin line work you can use a Series 56, size No. 1 sable (not illustrated). I recommend that you use a Staywet palette; it will stop your paint drying on the palette and keep it moist. You can use a gel retarder to keep the paint wet on the canvas longer. For a painting surface you can use paper, board or canvas (board and canvas are illustrated). An HB pencil, kneadable putty rubber, a paint rag and water jar complete this sketching set.

Oil colour (fig. 7) You will need a box to carry around your paints. The one illustrated takes everything, including paints, except the rag, and also works as an easel which you can rest on your knees. This box can be bought empty or complete with materials. Naturally, you can use an old holdall or a small suitcase. The brushes are Series 123 (bristle), sizes Nos. 4, 6, 8 and 10, and a size No. 6 sable (round). You will need a palette knife, purified linseed oil, turpentine, gel medium for speeding up the drying of the paint, canvas board, palette, dippers for holding your linseed oil and turpentine, an HB pencil, a kneadable putty rubber and some rag.

Pastel colour (fig. 8) To start with use either of the two boxes I mentioned earlier. The one illustrated contains 12 colours for landscape painting. You will need some paper or a pastel sketch-pad with a selection of coloured sheets. You will also need some fixative, a bristle brush for rubbing out areas of pastel, a kneadable putty rubber, an HB or 2B pencil and a piece of rag for cleaning your hands.

The subject of paper, unfortunately, is too broad to tackle in the limited space here. If you don't understand what is meant by the name of a paper I have mentioned, someone in an artists' supply shop will be able to help you.

Don't forget that materials, whether they are brushes, paints, paper, or even the stool you sit on, are all a very personal choice. Generally, the choice emerges through hours of practical experience and experiment. It is very difficult for the beginner to have the courage, let alone the knowledge, to go into an artists' material shop and buy the correct materials without guidance. I hope that by taking my advice you won't have to worry about what to get, as all the materials shown here are of the best quality available and will be in all good artists' material shops. If you have any worries, take this book along to a shop, open it at this page and, lo and behold, your materials will appear!

BEGINNERS' BASIC SKETCHING SETS

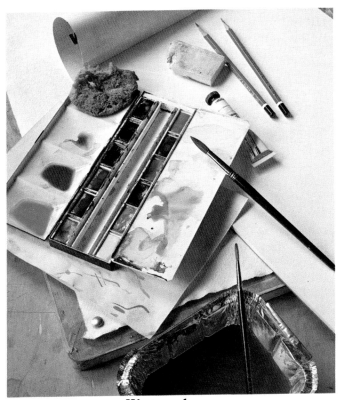

Fig. 5 Watercolour

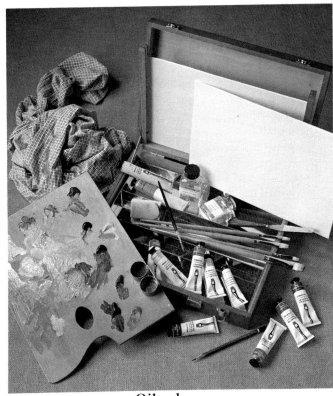

Fig. 7 Oil colour

Fig. 6 Acrylic colour

Fig. 8 Pastel colour

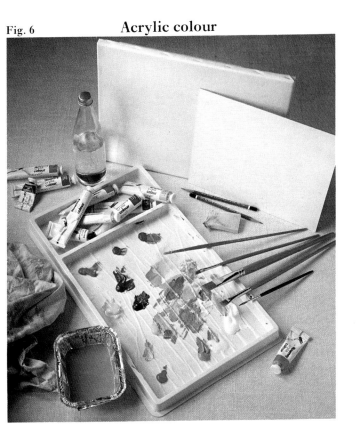

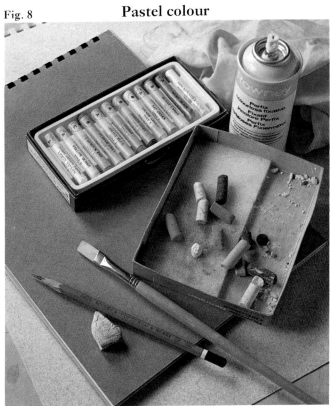

ELEMENTARY DRAWING AND PERSPECTIVE

A drawing is usually the groundwork for a painting, and therefore we will take some time to practise simple perspective before you start your painting. If you think you can't draw, don't let it worry you. Some artists can paint a picture but would have difficulty in drawing it as a drawing in its own right. A painting is made up of broad masses of colour, shapes and tones and it is these that make a painting. Generally speaking, if you want more detail in a picture then you will need more drawing ability, and this can only be achieved by plenty of practice. Back through the ages artists have looked for ways of making drawing simpler and some drawing aids have been invented. There is a very simple but very effective drawing aid on the market today, called a Perspectograph – it actually sorts out the perspective for you. Those of you who have not painted before will still be familiar with these terms: horizon, eye level and vanishing point; but now let us see how we use them in drawing.

When you look out to sea, the horizon will always be at your eye level, even if you climb a cliff or lie flat on the sand. So the horizon is the eye level (E.L.). If you are in a room, naturally there is no horizon, but you still have an eye level. To find this, hold your pencil horizontally in front of your eyes at arm's length and your eye level is where the pencil hits the opposite wall. If two parallel lines were marked out on the ground and extended to the horizon, they would come together at what is called the vanishing point (V.P.). This is why railway lines appear to get closer together, and finally to meet in the distance – they have met at the vanishing point.

Now look at **fig. 9**. I have drawn three red squares. In the first one (A) I have drawn a line through the middle of the square representing the eye level (E.L.). Then at the left-hand end of the eye level I have made a mark, the V.P. With a ruler I drew a line from each of the four corners of the square, all converging at the V.P. This gave me the two sides, the bottom and the top of the box. To create the other end of the box, I drew a square parallel with the front of the box and kept it within the V.P. guidelines. The effect is that of a transparent box drawn in perspective. I have called it the normal view.

In the drawings (B) and (C) the same box was used, drawing it exactly as in (A), but the eye level has been moved. In (B) the eye level is very low – a worm's eye view – and in (C) the eye level is very high – a bird's eye view. You can see from this exercise that the eye level is very important. It must be the first factor you locate when you are out sketching. Once your eye level is fixed on your paper everything else will fall naturally into place.

Fig. 10 shows our box drawn again from the bird's eye view, only this time I have painted the box to make it look solid. Try this exercise – it's simple, but it is the most

Fig. 9

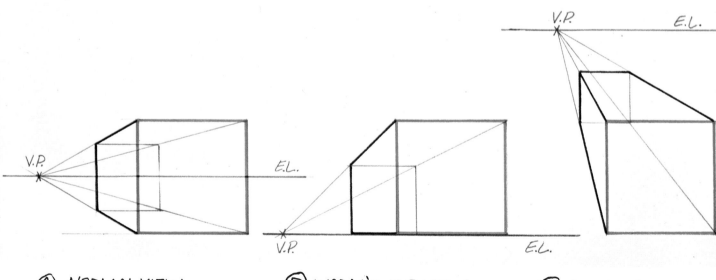

(A) NORMAL VIEW (B) WORM'S EYE VIEW (C) BIRD'S EYE VIEW

important exercise you will ever undertake. You are creating on a flat surface the illusion of depth, dimension and perspective; in other words, a three-dimensional object. If you have never painted before and are a bit afraid of starting with painting within a given shape, then read the next section first and come back to this one later.

One of the reasons that our box in **fig. 10** looks three-dimensional is because of the light and shade (light against dark) that shows the form. It is this light against dark that enables us to see objects and to understand their form. For example, let's think about a blue box painted on a background of the same blue. If there were no light or shade (light against dark) it would look like **fig. 11**A; if light and shade were added, it would look like **fig. 11**B. You must always be conscious of light against dark whenever you are painting.

In the same way that our box was drawn, clouds can be drawn in perspective in a *very simplified* way (see **fig. 12**). When you are out sketching, you won't be drawing clouds in the way I have shown in **fig. 12**, but by seeing what happens to nature – with respect to perspective – it will help you to draw with more conviction. When you look at the sky, do so through half-closed eyes. The lights and darks of the clouds will be exaggerated and the middle tones will tend to disappear. This gives you strong, contrasting shapes to which you can work. Use this method of looking through half-closed eyes next time you are out sketching – it will enable you to see definite shapes of the landscape and make your drawing easier. It will also help to simplify your work so that you are not trying to run before you can walk. The first steps into landscape painting must be thought out carefully, and under no circumstances must the beginner try something far too ambitious. To have spirit and self-confidence is fine, but if you try for the unobtainable, the mere fact of not reaching your desired result could ruin your confidence and put you back a long way. On the contrary, if you had a go at a simple subject and it came off to your satisfaction, that result would boost your confidence and you may never look back. *Always* have spirit and determination, but remember the old saying: 'Don't try to run before you can walk.'

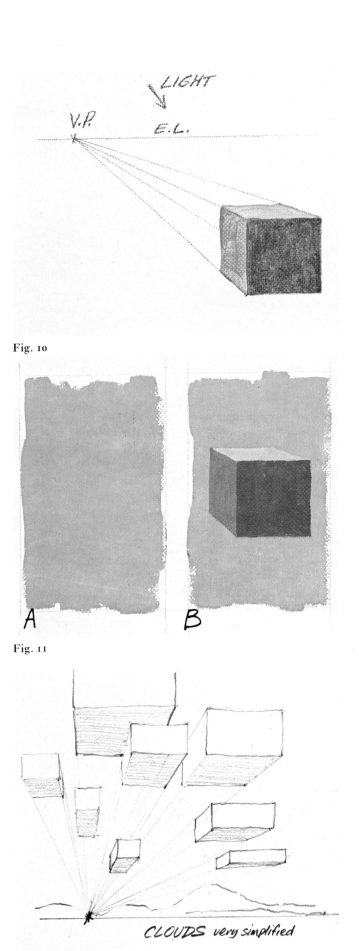

Fig. 10

Fig. 11

CLOUDS very simplified

Fig. 12

LET'S START PAINTING

Fig. 13

PLAYING WITH PAINT

At last you can start painting. Those of you who already own paints have made your own choice of medium, for various reasons, and can proceed. But for those of you who have not decided what medium to start with and are looking for guidance from this book, I can only say that it is a personal choice. If I *were* to make a generalization to help you to choose, I would suggest watercolour. The reason is that most of us used a water-based paint as children. Therefore, we began by putting water on a brush and mixing it into the paint. This, of course, was a very basic way of watercolour painting, but I suggest you start with this medium because most of you will be more familiar with it than anything else. For the beginner, it is also the most convenient medium.

A lot of people who have not painted before find that the most difficult bridge to cross is actually to put paint on paper. We are all self-conscious when it comes to things we have never tried before, and families and friends often don't help with their criticisms! It so often happens that someone sees a first attempt at painting and makes such remarks as: 'What's that?' and 'Oh well, never mind', which are not meant to hurt or to be unkind but, unfortunately, can upset and put off a sensitive beginner – sometimes for good!

If that problem arises this is how we should overcome it. It is part of our human nature to strive and to do better than the last time but, as I have said before, we must not try to run before we can walk. If we do this disaster will strike, followed by those humorous comments from the family. So we will start at the beginning and take things in a steady, progressive order – I'll see you don't run too soon.

Let us take colours as our first step into painting. The hundreds of colours that exist all around us might present an overwhelming problem for a beginner. But this can be simplified as there are only three basic colours: red, yellow and blue, which are called primary colours (see **fig. 14A**). All other colours and shades of colour are formed by a combination of these three colours. In painting, there are different reds, yellows and blues which we can use to help to recreate nature's colours. If you look at **fig. 14A** again you will see that there are two samples of each primary colour.

Now get yourself a piece of paper, a sheet from your sketch-pad will do, or a piece of white cartridge paper and literally 'play' with paint on it. See what the paint and

brush feel like; add more water, use less water – try anything you like to get familiar with the medium. You will finish up with a funny looking, coloured piece of paper but you will understand the paint and its application a lot more than before you started. You will also have broken the ice and actually started! Whichever medium you have decided to start painting with, play with the paint first, before mixing colours. **Fig. 13A** shows my doodles in watercolour and **fig. 13B** my doodles in oil colour.

Incidentally, if the family laugh at your first doodles, laugh with them, show them mine, and laugh at mine! Now we can move on to the next stage. With your new-found confidence you will find it very exciting.

MIXING COLOURS

As we progress through the exercises I will help you as much as I can, but first you must spend some time practising mixing different colours. In **fig. 14B** I have taken the primary colours and mixed them to show you the results. In the first row, Cadmium Yellow is mixed with Cadmium Red to make orange. To make orange look more yellow, add more yellow than red, and vice versa if you want it more red. Add White to make the orange paler. In the second row, Cadmium Yellow is mixed with Ultramarine, and this makes a green. If you then add White, you finish up with a light green.

You may have noticed that my lists of paint colours on p. 12 do not include Black. Some artists use Black and others don't. I am one of the don'ts. I don't use it because I believe it is a dead colour – it is too flat. Therefore, I mix my blacks from the primary colours, as shown in the third line in **fig. 14B**. It can be difficult for beginners to get really dark colours at first and if you get frustrated, I don't mind you trying Black, but do use it very sparingly. Remember that, in general, if you want a colour to be cooler, add blue, and if it is to be warmer, then add red.

Now instead of just playing with paint I would like you to practise mixing different colours. Mix these on your palette with a brush and paint daubs on your paper or canvas. Don't worry about shapes – it's the colours you are trying for. Experiment and practice are the only real guidelines I can offer you here. Next time you're sitting down watching television, look around you; pick a colour and try to imagine what other colours you would mix to obtain it.

One last important thing: when there are only three basic colours, it is the amount of each colour that plays the biggest part in mixing a colour. You can easily mix a green as in the second line in **fig. 14B**, but if it is to be a yellow-green, you have to experiment on your palette; you have to mix and work in more yellow until you have the colour you want. This lesson of mixing colours is the one you will be practising and improving upon all your life – I still am.

There is a very good aid to colour mixing that you can buy in art material shops. It is manufactured by Rowney and simply called a Colour Wheel. It is illustrated in **fig. 15**.

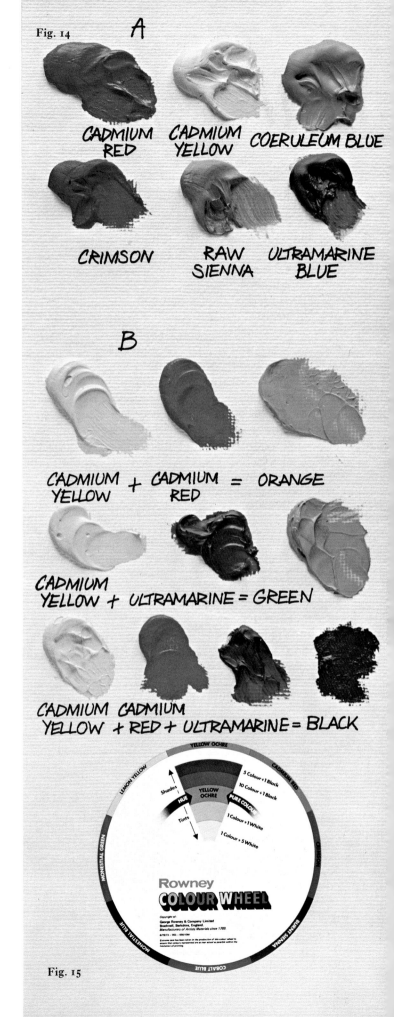

Fig. 14

A

CADMIUM RED CADMIUM YELLOW COERULEUM BLUE

CRIMSON RAW SIENNA ULTRAMARINE BLUE

B

CADMIUM YELLOW + CADMIUM RED = ORANGE

CADMIUM YELLOW + ULTRAMARINE = GREEN

CADMIUM YELLOW + CADMIUM RED + ULTRAMARINE = BLACK

Fig. 15

LANDSCAPE INGREDIENTS
SKY

We are now ready – if you have practised mixing your colours – to attempt some simple exercises. These are to be treated in *broad terms; don't try to put much detail in them.* Copy my exercises from the book, as this will make you more familiar with the subject when you paint out-of-doors on location. I can't stress too much the importance of being familiar with your brushes, paints, colour mixing and now your subject matter. The more familiar you are with your medium or subject, the more confidence you will have. The more confident you are, the better your paintings are.

I have taken the four main ingredients of landscape – sky, trees, water, and ground and snow combined – to use for these simple exercises, starting with the sky. These are general notes that apply to the subject, in this case sky, and therefore would adapt to any medium you are using. If I have worked an exercise in watercolour, for instance, and if you are working in acrylic colour or pastel then have a go with your chosen medium. Remember that the object of these lessons is to practise and to learn.

Before we start, let us consider our first landscape ingredient – the sky. Whatever type of landscape you paint, and in whatever medium, the sky has always, in my mind, played the most important role. It is the sky that conveys to us the type of day it is, whether it is sunny, cold, blustery, rainy, etc; even from indoors one look at the sky can usually indicate what it is like outside. The sky is the all-embracing mood in which the landscape sits. If this mood is captured by the painting of the sky, then this mood will follow naturally through to the rest of the painting. As I have said earlier, our senses help us to keep the mood of a painting alive. In the same way, once you have painted

the sky, you are constantly being reminded of the type of day you are painting. If you paint a sky with feeling and atmosphere you can go on to paint a masterpiece. If your sky hasn't got atmosphere or feeling, that landscape can never become your best work.

When you feel you are ready to paint skies out-of-doors from nature, you will find it very confusing because the clouds will not stop for you! Naturally some clouds – those in the distance – appear to move much more slowly than those immediately above us, and therefore allow us to take more time to paint them. But we must accept the fact that the sky moves and we have to paint it while it is moving. The answer to this is to start by doing pencil sketches. You can do enjoyment, information and atmosphere sketches. Keep a sketch-book for skies only; it will become an important source of reference to you. Use a 3B pencil or, if you find this a little too soft, a 2B pencil, and a kneadable putty rubber for rubbing out highlights.

The secret of drawing moving clouds is to look at the sky and watch the pattern of movement. Observe which banks of clouds are moving behind others, which are moving fastest and so on; also, half-close your eyes and see the mass of shapes in a more simplified pattern. When you have got the 'feel' of the sky and its movements, wait for a descriptive formation to unfold – look hard at it, hold your breath and off you go!

Start in the middle of the paper, as this will give you room to manoeuvre in any direction, and draw roughly the shapes of the clouds. Then, very broadly, shade in the areas of tone. Naturally, depending on the speed of the clouds and your speed, the formation you started with will

These two atmosphere sketches, both 17 × 20 cm (6½ × 8 in), were done with pastel on an Ingres paper

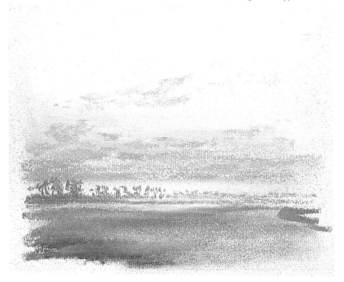
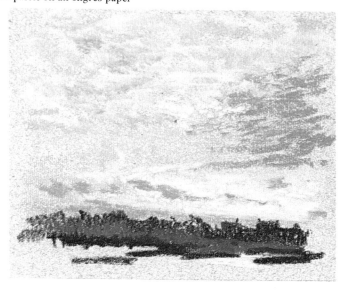

have changed, but because you have observed the nature of cloud movement you will be capable of a little 'ad lib'. Under no circumstances, once you have decided your sky formation and started, should you try to alter what you have done to look like the changed sky -- it will change again and you will be left 'in the clouds'. If you have to change because the sky has developed into an absolute beauty, then start again on another page. Don't do these sky studies any larger than 20 × 28 cm (8 × 11 in) and you can sketch them as small as 13 × 10 cm (5 × 4 in).

When you have gained enough confidence working in pencil, have a go with colour. Incidentally, on all your sketches from life, especially skies, make a note of the time of day, position of the sun, type of day and the date. This information will help you to understand the sketch totally at a later date.

The method of painting skies is just the same as pencil sketching. When painting, try to use as few colours as possible to start with, because if you spend too much time mixing colours the sky will have moved on. Even with paint try to work as small as 13 × 10 cm (5 × 4 in). Whenever you paint a sky add some part of the landscape, even if it is only a low line of distant hills. This gives the sky depth and dimension. Pastel is a good medium for quick sky studies. With the long edge of a pastel you have a quick and sensitive medium for covering large areas of colour.

SIMPLE EXERCISES

I worked all the paintings for these simple exercises dealing with landscape ingredients twice the size they are reproduced here. They are shown in two or three stages so you can see how the sketches were developed.

The first exercise (**fig. 16**) was painted in oil colour on canvas board. It is of a blustery day with clouds moving fast over the sky, leaving parts of the landscape in rain and others in brilliant sunshine. To make it simple I used only three colours and White. Work with a size No. 8 bristle brush for the whole of the painting. Where the colours are darker use less White. When you paint the rain in the distance let the brush strokes show the direction of movement, and paint over the horizon. When you paint the distant hills, paint *over* the bottom of the rain with horizontal brush strokes. This painting was done in one sitting, and therefore painted 'wet on wet'.

Fig. 17, a watercolour, was worked on GREENS RWS 140lb NOT SURFACE watercolour paper. I find that this is a paper that suits my type of work and I use it for nearly all my watercolour painting. Don't do any drawing for this sky, just start at the top with your size No. 10 sable brush. Use plenty of water mixed with Coeruleum Blue and Crimson Alizarin and let the brush strokes form the clouds. When the first stage is nearly dry, add Yellow Ochre to the colour in your palette and then paint the cloud shadows and distant clouds. Letting the brush do the drawing, paint the landscape with French Ultramarine and Cadmium Yellow Pale.

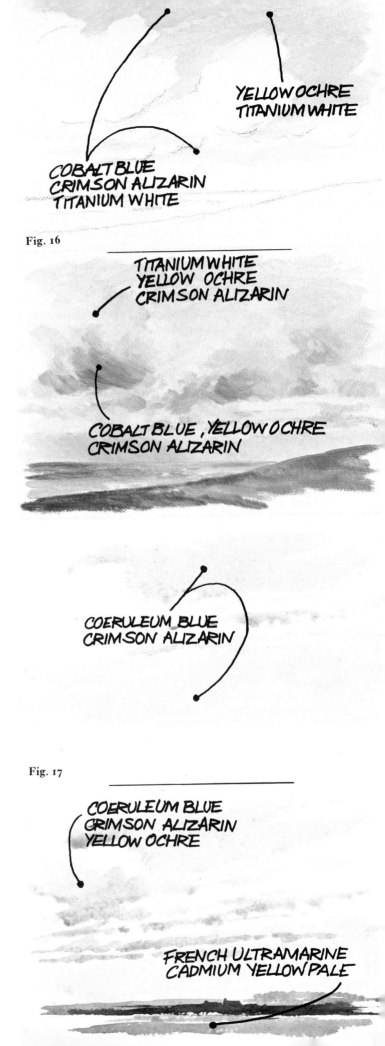

YELLOW OCHRE
TITANIUM WHITE

COBALT BLUE
CRIMSON ALIZARIN
TITANIUM WHITE

Fig. 16

TITANIUM WHITE
YELLOW OCHRE
CRIMSON ALIZARIN

COBALT BLUE, YELLOW OCHRE
CRIMSON ALIZARIN

COERULEUM BLUE
CRIMSON ALIZARIN

Fig. 17

COERULEUM BLUE
CRIMSON ALIZARIN
YELLOW OCHRE

FRENCH ULTRAMARINE
CADMIUM YELLOW PALE

LANDSCAPE INGREDIENTS
TREES

The tree is nature's most valuable gift to the landscape artist when it comes to the composition of a picture. For instance, one lone tree can make a picture. Trees can be used to break the horizon line; they can be positioned to stop the eye going forward or to lead the eye into the picture. Go out on sketching trips to sketch only trees; in fact, it would be a very good idea to use a small sketch-book just for trees as I have suggested you do for skies.

Before you start painting trees, learn to draw them first. Find a good looking tree out of leaf, if it's the right time of the year, and make an information sketch of it. It is very important that it is drawn as carefully and as detailed as you can. The more you work at that sketch, trying to draw every branch, the more you are learning about the tree – its form, growth pattern, size, and so on. After you put down your pencil (your fingers and wrist still aching), you will realize just how much you have learned about that one tree; you will feel quite attached to it. Then use a sable brush and just one colour and do the same exercise with brushwork. When the leaves come out on the trees, go out and sketch them again, using pencil first. Look at the

overall shape of the tree to get its character. You will find that there are always areas of sky showing through somewhere in the tree, and you will always be able to see some branches. Never make a tree look like a solid lump of Plasticine; even if the tree is a full mass of leaves, like a large chestnut can be, there will still be light and shade in the pattern of foliage. Use the 'half-closed eyes' technique to its full advantage and pick out the different tones and shapes of the leaf masses. Shade them in with a 3B pencil and make particular note of the leaves that show dark or light silhouettes against the sky. These areas 'clean up' the tree, give it sparkle and help to identify the species. Work your first sketch of a tree in leaf from a distance of about 275 metres (300 yards). From this distance you will see only the broad shape and character of the tree and you won't be tempted to worry about the detail – you will not see it from that distance! Then sketch from closer positions until you are close enough to make separate studies of areas of branches and leaves in the tree. When you get very close and look into the tree, you will have to half-close your eyes to pick out the shapes you have to draw. When you feel you are ready to work in paint, work very broadly to start with, looking for the large mass areas of leaves first, then break those areas down into smaller areas of shape, colour and tone. Start again from about 275 metres (300 yards) and work closer as you gain confidence. Don't put too much detail in your middle-distance trees or you will find them jumping out of your picture. Whether you are using pencil, brush or pastel, always draw the tree branches in the direction in which the tree is growing. This will help tremendously to create a sense of growth and reality.

When you start to draw a tree, start at the base of the

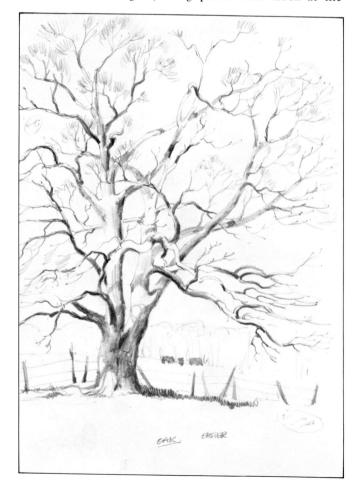

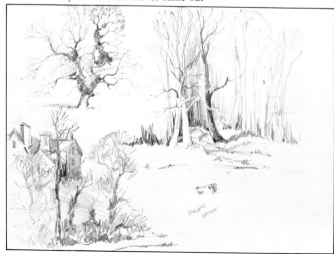

These information pencil sketches of trees were done over the Easter holidays before the leaves came out

trunk and work upwards as though the tree were growing
from your pencil or brush. Where the tree is mostly foliage,
let the brush strokes follow the direction of the 'fall' of the
leaves. When the brush gets too big for smaller branches,
change to a smaller brush. It is often tempting to go on a
little too long with the big brush because you are 'in the
swing of it', but don't – change brushes! Finally, trees may
look alike but they are all individual, so paint *your* trees as
individual characters of nature.

SIMPLE EXERCISES

The first tree exercise (**fig. 18**) was worked in watercolour
on GREENS RWS 140lb NOT SURFACE watercolour paper. With
an HB pencil only, draw the land area and the trees – no
detail in the foreground tree. Then paint the sky with your
size No. 10 sable brush, just as you did in the first sky
exercise, but add Cadmium Yellow Pale to the Crimson
Alizarin near the horizon. When the sky is dry, paint the
distant trees, changing to your size No. 6 brush. While
they are still damp, paint the two poplar trees, the two
smaller trees, and the field underneath. Now paint the
trunk of the main tree and the main branches. While it is
still wet paint the foliage, using your brush on its long edge
and dragging it sideways and down to get a leaf effect.
With the same colour, and while it is still wet, paint the
shadows on the trunk. With the same size No. 6 brush and
the same colour paint the ground and draw the fence and
gate with the brush at the same time. Don't try to copy
exactly the shapes I have in my painting. This is not
possible because *your* brush strokes will determine *your*
foliage shapes.

The next exercise (**fig. 19**) I have done as a very simple
but effective tree study in pastel. I used Ingres paper and
painted it with only five pastel colours. Start by drawing
simple shapes of the tree areas with an HB pencil or, if you
like, go straight in with pastel. Paint the background trees
with Indigo Tint 3, using the broad edge for shaping the
tops of the trees and the blunt edge for drawing the trunks.
Drag the sky pastel, Yellow Ochre Tint 2, down and into
the distant trees. Using Sap Green Tint 3, paint the field,
working slightly into the blue trees above. Then use Green
Grey Tint 6 to paint the hedge of trees. Apply more
pressure to this work to give more density to the trees.
Draw the branches as you go; don't try to copy mine
exactly or they will not flow. With the same colour paint the
ground and fence. Finally, add Ivory Black to the nearest
trees to keep them in the foreground.

A little painting like this should not take a lot of time
because it is very free and spontaneous. If you enjoyed
doing this one, do lots more, varying the composition and
design. Use different coloured papers and try adding some
pastel colours of your own choice. You will finish up with
some very nice paintings and a lot more experience.

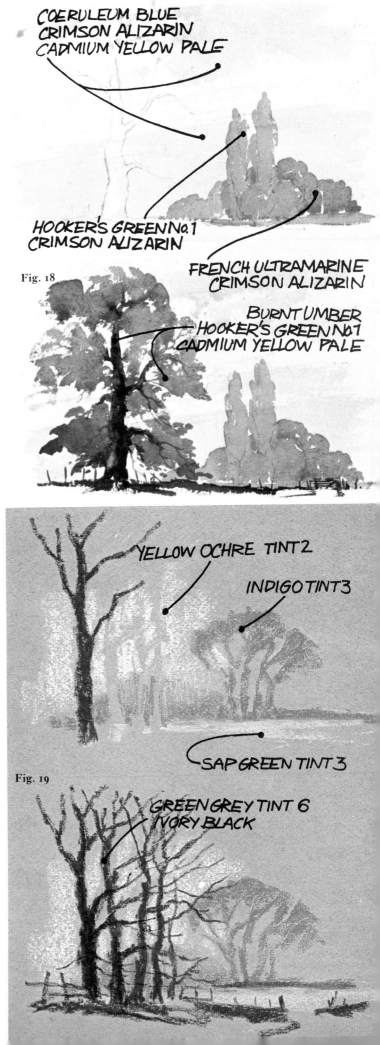

COERULEUM BLUE
CRIMSON ALIZARIN
CADMIUM YELLOW PALE

HOOKER'S GREEN No.1
CRIMSON ALIZARIN

FRENCH ULTRAMARINE
CRIMSON ALIZARIN

BURNT UMBER
HOOKER'S GREEN No.1
CADMIUM YELLOW PALE

Fig. 18

YELLOW OCHRE TINT 2

INDIGO TINT 3

SAP GREEN TINT 3

Fig. 19

GREEN GREY TINT 6
IVORY BLACK

LANDSCAPE INGREDIENTS
WATER

Water is a very exciting subject to paint. It has so many moods, and like the sky it is always changing. I have always been fascinated with water. I am a keen angler and I have observed water in limitless moods, from sunrise to sunset; misty, clear and muddy, and I still get excited about painting it. There are certain rules that must be observed and the first and most important of all is that all movement lines or shapes must appear *perfectly horizontal* on the canvas or paper, otherwise you will have created a sloping river or lake!

The biggest worry that I find most students seem to have about painting water is the colour of it. As with all subjects, the secret is observation and then simplification of the shapes and tones, as you did for your trees. The colour of water is dependent on its surroundings, as the objects the water reflects – sky, trees or buildings – will reflect their image in shape and colour, and hence will determine the colour of the water. The reflected colours are slightly darker than nature; this must be remembered when you are painting.

As you did with the sky and trees, start by sketching in pencil. When you are out for the first time, try if possible to find *still water* with good reflections. Sit down and look at the water and its surroundings, half-close your eyes and see the shapes and tones of the reflections. Then, when you are confident that you have simplified the shapes in your mind, make a pencil sketch with a 3B pencil, or try using just two or three tones of pastel colour. You can put in some reflected highlights with a putty rubber, using

horizontal strokes to take off the pencil. This gives the appearance of ripples.

Painting moving water with reflections is a little more difficult because, as with the sky, it won't keep still. Look at the water and surroundings and try – practise this – to keep your eyes in one place, i.e. don't let the flow of the water take your eyes with it. If you can do this you will then be able to make out the shapes and colours of the reflection. The reflection stays in one place, it is only the reflected light, water plants and floating flotsam on the water that represent movement. The movement breaks up the shapes of the reflections and gives them strange shapes, but with half-closed eyes you should be able to sort out the major shapes and forms. Try not to fall into the too familiar trap of painting horizontal lines all over your water, as this tends to make it artificial and contrived. Keep horizontal lines to a minimum and use them for very definite effects of water movement or reflected light.

If you feel like being very creative, sketch water reflections without the surroundings; in other words, let only the water be the picture. You can simplify and push around the reflections to create wonderful designs and shapes. This is also a very good exercise to get to know your subject. Don't overwork water when you are painting it. If you are using watercolour or pastel, for instance, the paper can even be left unpainted to represent the water. If you are working in oil colour or acrylic colour don't use thick paint unless it is for movement or for highlighting the water.

A little psychological trick I use from time to time is to

Fig. 20

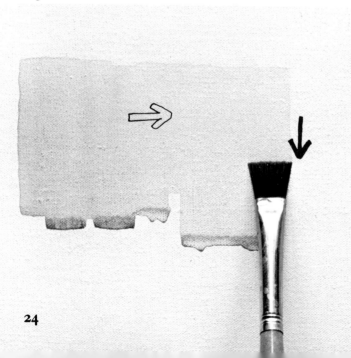

Fig. 21

add a reflection in an area of 'unreflected' water and this automatically conveys to viewers that they are looking at water. A puddle in the countryside could have a broken branch reflected in it, or a fence, long grass and so on. Use these 'trump cards' when nature lets you down and you are left with a flat, 'unwateristic' area of water.

In **fig. 20**, you will see two arrows: one is solid black and the other is outlined. *I will be using these arrows in various places in the book to help you to understand the movement of the brush.* The solid black arrow shows the direction of the brush stroke and the outline arrow shows the direction in which the brush is travelling over the paper. For example, **fig. 20** shows the brush stroke moving vertically from top to bottom, and the brush moving to the right after the completion of each vertical stroke. **Figs. 20** and **21** show how you can very easily give the impression of puddles of water with acrylic colours. First paint the water (**fig. 20**) as a watercolour wash – very wet. Paint in downward strokes. When it is dry, paint the earth around it (**fig. 21**) but keep your shapes in perspective or the puddles will not lie flat. If you want light coloured earth, paint the water darker.

SIMPLE EXERCISES

In your first exercise (**fig. 22**) I have shown how you can use a reflection to give the effect of water. In this case, allow the white paper to show through as water. With your size No. 10 sable brush, paint the background field, then change to your size No. 6 sable brush to paint the fence. While this is still damp, paint the long grass, going over the main post. If you look at the first stage only, the white area underneath the fence could be anything from snow to paper, but by adding reflections it undeniably becomes water. Work the reflections with your size No. 6 sable brush, and keep them very free; do not labour them.

The next exercise (**fig. 23**) may appear more complicated than the previous watercolour. In some ways it is (you should be ready to try it by now anyway – don't get 'wet' feet!), but I have kept the colours down to only three, plus White. It is painted in oil colour and worked on a canvas board. Note the colours in the first stage, and then work the reflected colours from the same ones. Paint the first stage with your size No. 8 bristle brush. Then concentrate on the reflections in the second stage. This exercise is really an exercise in reflections. Work out the shapes between the branches – for this use your size No. 4 brush – trying to simplify even my painting. Work at this one, and if it doesn't come off the first time, try again.

Try holding something over or against your dirty paint water in your water bowl, work out and simplify the reflection you see, and have a go at painting it. Dirty water helps to hold the reflections together and makes them less complicated.

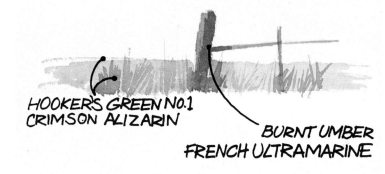

HOOKER'S GREEN NO.1
CRIMSON ALIZARIN

BURNT UMBER
FRENCH ULTRAMARINE

Fig. 22

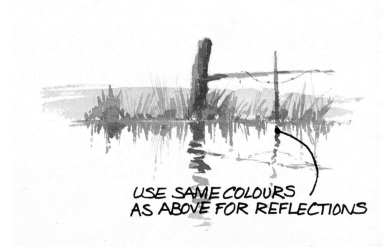

USE SAME COLOURS
AS ABOVE FOR REFLECTIONS

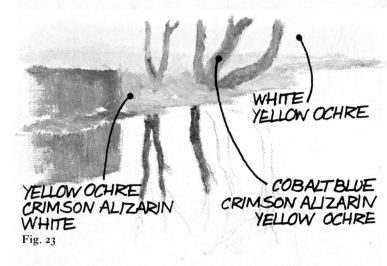

WHITE
YELLOW OCHRE

YELLOW OCHRE
CRIMSON ALIZARIN
WHITE

COBALT BLUE
CRIMSON ALIZARIN
YELLOW OCHRE

Fig. 23

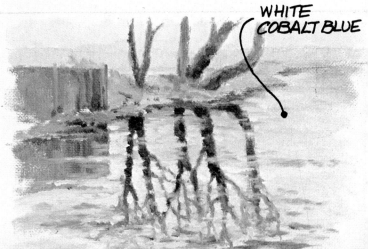

WHITE
COBALT BLUE

LANDSCAPE INGREDIENTS
GROUND AND SNOW

The 'ground' in a landscape is very important as it usually represents the nearest part of the painting to the viewer. This means that in most cases – not all – it will have to show the most detail relative to the painting. That detail could be slight, depending on the subject or the style of painting, but in many cases it would have to represent a true and detailed account of itself. This brings me back to my 'thing' – observation! I am certain that there is one thing you will have learned after reading this book, and that is how to observe, and the importance of it! If this is the case, I will not have wasted a minute of my time. If you can observe you can become your own teacher, and with practice you will be painting happily for the rest of your life, and that will certainly make me very happy!

Meanwhile, let's get back to the sketch-book and a 3B pencil. Go out into the country or in your own garden and sit, look and observe. This is where the information sketch is really necessary. You are working for information that can't be suggested, you must draw to learn what happens to things – how a fence goes into the ground; a cart track is formed; grass grows; wild flowers grow, and so on. If your drawing isn't that good at the moment, then try painting direct what you see, to create the effect.

A word of warning when painting close-up detail: if you are painting a tree in leaf on a canvas, say 25 × 20 cm (10 × 8 in), the leaves, to be in scale, would have to be smaller than a full stop on this page. You would paint that tree by defining groups of leaves as detail, not each single leaf. This point is very important as a painting can be spoiled by detail – no matter how good – being worked in the foreground completely out of scale. When you are out sketching for this exercise, always make sure you put something in your picture that denotes scale. If there is nothing definite around, then sketch your stool, your hat, or a dog in the picture. This need be done only simply, but it will give scale to your sketch and I can't stress enough how important that is. When you are working on the foreground and you are painting grass, bracken and other things that grow, work your brush strokes in the same direction as their growth and movement. Every brush stroke conveys a story, and you should take advantage of this, especially in close-up work.

Snow can give you lots of pleasure in painting it. It does have its natural problems for sketching and working out-of-doors. But if you can get the car out on the road you can always work from its relative comfort or, alternatively, at home from a window. The stillness and quietness of a snowy landscape can be unbelievable. The clear rivers of spring and summer turn to brown, and trees stand out in sharp silhouette. A pencil sketch of a snow landscape can be very rewarding, with white paper showing through to suggest snow and with areas of dark pencil tone to suggest trees and hedgerows. Beware when you are painting snow – never use White paint for any of it. It is only white in its purest form – just fallen – and even then it reflects light and colour from its surroundings. Even the whitest snow should have some colour. Add a little blue to cool the White paint or a little red or yellow to warm it up. Never be afraid to

Fig. 24

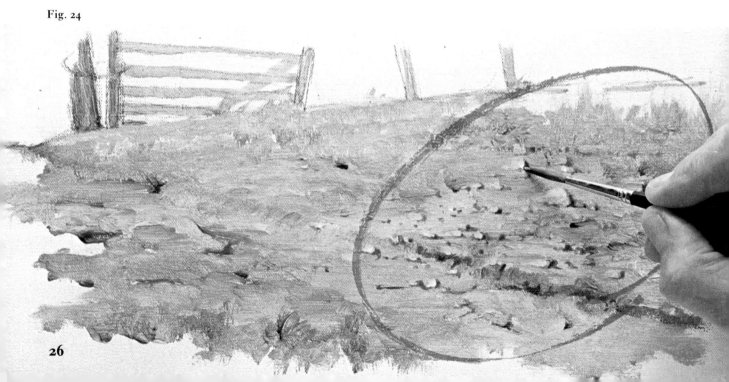

make snow dark in shadow areas. It can be as dark, in comparison to its surroundings, as a shadow in a non-snow landscape. Paint snow in a low key: if we take our darkest shadow as number ten and our brightest snow as number one, with a natural gradation of tone in between, you should paint your snow in the range from eight to three. This will leave enough reserve up your sleeve to add darker shadows and brighter highlights.

SIMPLE EXERCISES

Fig. 24 shows a simple yet very effective way of painting ground. I painted this in acrylic colours on an acrylic primed canvas, using Crimson, Bright Green, Cadmium Yellow, Raw Umber, Ultramarine and White. This same technique can be worked with oil or watercolour. Paint the area you want as mud/earth and work your brush in a horizontal scrubbing motion. This will leave light and dark areas of different tonal values. If there are any wheel tracks in the path then suggest these while you are painting it.

When this is dry, look hard at what you have achieved, pick out the areas in your painting that look like stones or lumps of dried earth and paint a shadow side to them with your size No. 6 sable and a watery mix of Ultramarine and Crimson. When you have done this, add some highlights (by adding White to the original colours you used for the ground) and the result can be quite remarkable. By looking at fig. 24 after reading this explanation you should understand what I did to achieve the realism in the ground. The area that I have finished is in the red circle. The area outside was how it started. This technique is really a very controlled happy accident.

Now let's move on to the snow scene in fig. 25 painted in acrylic colours. Again I have simplified the exercise for you by using only three colours and White. I have also worked the painting on a tinted Ingres paper. This will enable you to see the 'white' colours you have put down for the snow. Draw the picture quite freely with a 2B pencil. Then paint the sky, distant trees and fields. Remember to paint all the snow, until the end, in the key of eight to three (see fig. 26). I used a size No. 6 nylon brush for all the painting except the branches of the large tree, when I used a size No. 6 sable brush. You will find that if you use acrylic colour on Ingres paper it will soak in quite fast. If you want to stop this happening, mix a little gel retarder with your paint. When you have finished, put in the highlights on the snow and the darkest areas. It is here that you move into numbers ten, nine, two and one of your snow key.

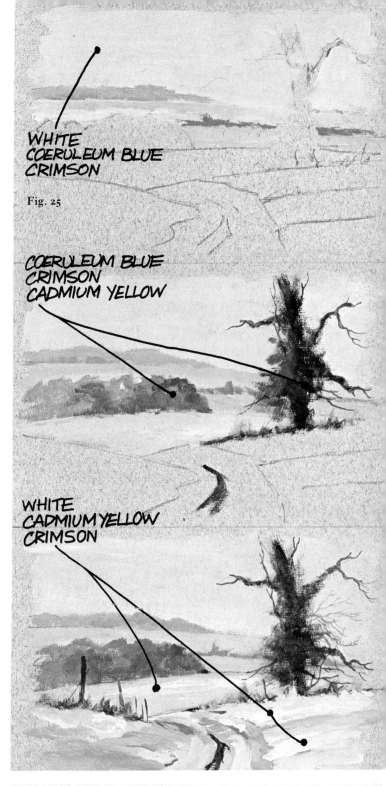

WHITE
COERULEUM BLUE
CRIMSON

Fig. 25

COERULEUM BLUE
CRIMSON
CADMIUM YELLOW

WHITE
CADMIUM YELLOW
CRIMSON

Fig. 26

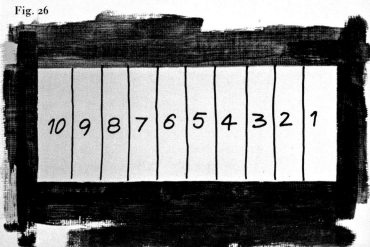

10 9 8 7 6 5 4 3 2 1

PAINTING FROM MEMORY

Painting from memory or imagination must be one of the most tried ways of painting landscape. I am sure that everyone who has used a pencil or paintbrush sometime in his life has sat down and painted a landscape from his imagination. Let me define what I mean by memory and imagination. If you were to paint a Martian landscape, it must come from imagination as you would have never seen one before. If you were to paint a Devon landscape and you had lived there, then it would be from memory, although some imagination is bound to creep in – not little green men but perhaps a gate or an old cottage. These are things you have imagined to help to create your picture, but even these you have seen somewhere, when you have been out walking, in a book or on television.

Therefore, to paint from memory means to make up a scene at home using your memory for information, even if some of this is subconscious. Imagination is there to add a little spice to the picture. Everything that we hear, say and see is stored away in our memory. But we need a trigger to bring it back. Take the smell of burning wood, the dawn chorus of the birds, a particular sunset – any one of these can trigger off a past visual experience. My memory banks are stored with information from countless hours of working outside and – dare I say it? – observation. The more sketching you do outside the more you will feed your visual memory banks and keep them active.

This way of painting can give you tremendous fun and excitement with total control over the subject, to leave you with all your concentration focused on painting. You are not in any way inhibited by copying; the cows are not getting into your equipment, and you haven't got your other eye on the weather! You are in total and complete control. There must be certain subjects that you would find more difficult than others. For instance, as I paint in a representational style I would not try to paint from memory a boatyard full of boats and marine bric-a-brac, with all the technical detail required. I think this would test my memory to the limits!

If I intend to do a serious painting from memory – by that I mean a finished picture, not an exercise or experiment – I have my own way of going about it. You will more than likely adapt your own, the means doesn't matter as long as you can enjoy your painting. Before I tell you how I do it, I still have the impromptu way that I think all of us use at some time or another. I can be out in the car and be inspired by a tremendous sunset or early morning mist, and as soon as I get back home I paint it. I can hold a vivid visual impression for about two days or so, then it slides into a file in my memory banks to be conjured up on another day.

I always sit in front of my easel with a blank canvas on it

(if I am working in acrylic colour or oil colour) and with a sketch-pad on my knees. The canvas is there to give me the visual shape and size of what I will be painting. On the sketch-pad I will draw the proportion of the canvas into which I will work my sketch. I usually work my sketch half the size of the painting, as it is then easy to scale up to the size of the canvas. The next stage is the most difficult but the most important. I sit quietly and imagine all different moods of nature: different days I have been out on a very hot day, a bright sunset, and so on. As I have said our memory banks are full of these visions and, depending upon the mood you are in, one of these will come to the surface. If you are feeling very satisfied and at peace with the world, then the chances are that you will relate your being to a peaceful early morning mist or a warm summer's evening – peace and serenity. On the other hand, a rough time with the children or a bad day at the office – and we all have these – and a stormy day with the wind blowing would be released from your memory banks.

Try this out just sitting quietly one evening, and see if it works under non-painting conditions – you might be surprised. If you find it difficult then you can use the television as a trigger. The only problem is that it might not be convenient to paint at that time. Try to hold the vision the television triggered until you can paint. Another way which can work nearly all the time is to look at the family

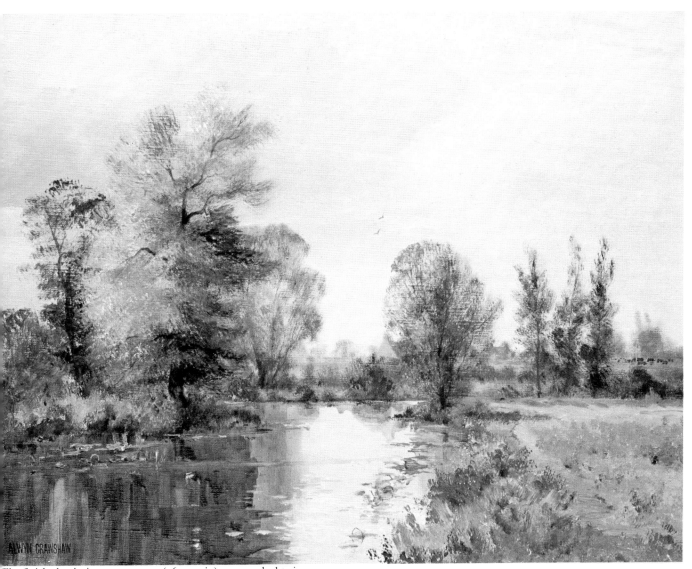

The finished painting, 41 × 51 cm (16 × 20 in), was worked twice
the size of the sketch illustrated opposite

photos. You will not necessarily find the scene that you
will paint, but you could find a trigger that will remind
you of a certain outing, and everything will come flooding
back including, of course, the mood of the day. Once you
are sitting in front of your canvas and you can feel the
mood, with all your thoughts and energies focused on one
intent – to paint that particular mood of nature – then you
are ready to prepare the sketch.

To capture a mood of nature in a painting gives a painting
life, whatever style you employ. Without it a painting is
dead. Now you have to decide on the content of the painting:
this can easily have been pre-ordained by the scene that
gave you the mood. If not, think about the mood you have
chosen. If it were a balmy late summer's evening then
serenity is called for. Avoid dramatic lines and shapes, trees
must have leaves, water would be calm with still reflections,
and so on. Now decide what is going to be the centre of
interest: a tree, a path, the sunset. If it were the late
summer's evening then the sun (sunset) could be the centre

of interest with a slow moving river catching the sunlight.
The horizon would be low because the mood is coming
from the sky, therefore the more sky there is the better.

I would then draw the sketch. The reason that I do not
draw directly on the canvas is that the sketch will be there
all the time so I can refer to it. The painting may well alter,
but you can always come back to base and look at the sketch.
I then draw on the canvas from my sketch.

I have got sketch-books full of this type of sketch and I
sometimes look through them to give me inspiration – the
sketches themselves are the trigger! Whatever you do while
you paint indoors like this, you must always keep 'the mood
of nature' you are portraying or your painting will end up
lifeless. If during a painting like this you change direction,
or even alter the goal you were aiming for, don't worry.
This is the beauty and fascination of painting from memory.
You are in control, *you* are creating your landscape and
your expression will be uninhibited. It is an exciting way
to paint – and I love it!

PAINTING FROM PHOTOGRAPHS

Whatever I discuss about the use of photographs in this section must be prefixed with the next sentence and remembered. *Photographs can never take the place of working directly from nature, or be a short cut to your own personal observation and experience of landscape.* Having said that, let us see how photographs can help us with our painting. First of all, I am an artist who agrees with the use of them, but as with all painting and drawing aids there are right and wrong ways of using them. I am sure, although unfortunately we will never know, that if the camera had been around in the days of Constable, Turner and many other great landscape artists they would have welcomed it.

In the same way, I am sure they would have been overjoyed to have had the use of electric light, which is frowned upon by some artists. I can't see the micro-chip helping the artist – yet – but let us take advantage where we can of any modern technology. After all, we now use and accept nylon brushes, but the only thing I remember being nylon 25 years ago were nylon stockings. We use and accept acrylic colours, we buy paints in tubes, but it hasn't always been like that.

It is very difficult to generalize about photographs but I will try. You must take your own photographs that you are going to use, you must have experienced the occasion. I use photographs in two ways: as 'information sketches' and 'atmosphere sketches'.

When I am out sketching in either pencil or colour, if it's a particular sketching trip and not an impromptu occasion, I bring my camera with me. After sketching the particular scene I take a photograph from my sketching position and then, depending on the subject, photograph particular details. When I am working from the sketch at home I have, *if I need it*, reference to detail information in my photograph. I always take slides, not prints. Slides give much more detail and depth, and you can enlarge a slide to a very large picture image if you want. When I am using a slide for reference while I am painting, I hold it in a small hand viewer.

The photographs I use for 'atmosphere sketches' are simply photographs to record moods of nature that I happen to see and have not got the opportunity or the time to record by sketching. On some occasions you might not have your camera with you; then try to observe the scene carefully and store it in your memory banks for future work. One of the biggest traps of all that you can fall into is to copy a photograph, even if your first intentions were to use it for information only. Do not try to reproduce a photograph in paint! It will lack life and feeling, and be totally void of your own expression and originality.

I have heard some teachers suggest that if a photograph were out of focus it would be better to copy from, because the detail would not be seen. I don't agree with this because I believe that to be able to paint anything you must know what you are painting, and if the photograph is out of focus or fuzzy then you do not necessarily know what you are trying to recreate. You might be painting a stone wall running down a field, when it really is a beech hedge. This is a very shallow way of working; in fact, all you are doing is copying images from a photograph – this is wrong. Get as much detail and clarity into your photograph as possible and you be the judge of what to put in or leave out. Remember that you are not copying – you are creating your own experience, not the camera's.

If you take a photograph from a sketching position, you will notice one very marked difference when you compare the sketch and the photograph at home. In your sketch you will have brought the distance and middle-distance much closer and larger than the photograph. Look at **figs. 27** and **28**: the sketch of Send Church in Surrey was done first and then the photograph was taken. I was surprised at how small the church was and at how I could hardly make out the anglers on the river bank. I think that, apart from technical reasons, the camera sees everything, but *you see only what you want to see.* (This is why your painting will always be different from the next artist's, even if you paint the same view.) In the sketch of Send Church I was not concerned with the fence or my son, Clinton, standing on the ice. I wanted to capture the church in the cold morning mist and the anglers standing there – waiting, frozen. I knew how they were feeling. The sketch took only about 20 minutes and *my* hands were frozen too.

Finally, I think the last trap to fall into is to fuss and worry about the photograph or the camera. You are outside learning to be an artist, not a photographer. Become a photographer by all means, but don't mix it with being an artist. When you are out working, the camera's purpose is to get information only, not to make pretty pictures. Your energies should be concentrated on your drawing or painting, not on the camera. The best way to get over this is to have a very simple camera, so that all you have to do is to press a button and the picture is taken. If you want to go out and use the camera for photography's sake, then don't take your sketch-book. Both painting and photography need undivided attention as they are both very creative and individual forms of art.

When I am teaching, students often come up to me and, in a very quiet voice, ask: 'Can I use photographs?', looking around quickly to see if their colleagues have heard. This confusion about the use of photographs should be dispelled once and for all. There is no crime in using photographs as long as you use them correctly, and never be afraid to say: 'Yes, I use photographs.'

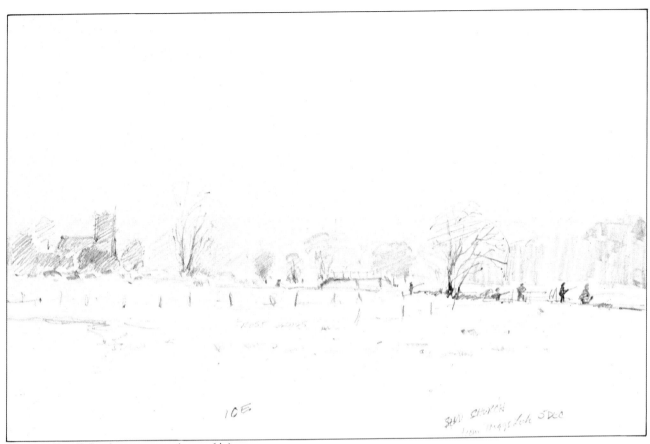

Fig. 27 Pencil sketch, 30 × 41 cm (12 × 16 in)

Fig. 28 A portion of the photograph I took of Send Church

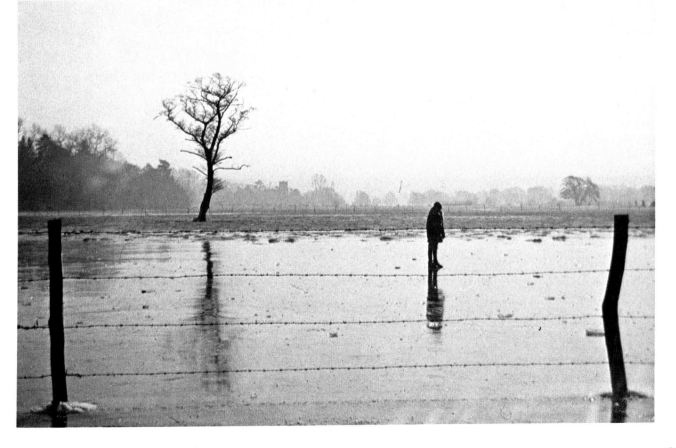

NOTES ON PENCIL SKETCHING OUT-OF-DOORS

I have said quite a lot so far about sketching and in particular sketching in pencil. You will be familiar with my definitions of sketches from an earlier section. I have illustrated the two most commonly used: information sketch (**fig. 29**) and atmosphere sketch (**fig. 30**).

Some very basic common sense rules prevail to working outside. The one thing that you can get caught out with most of all is not to put on enough clothing. Whenever you go out sketching take enough clothing with you; it can always be taken off, but if you haven't got it you can't put it on. And if you are not reasonably comfortable or warm you will not produce your best work. Keep your sketchbook in a polythene bag; I always have done so since I dropped mine in a pond! You will require two or three pencils, a knife to sharpen them with (incidentally, always sharpen them before you go out), a putty rubber and, of course, your sketch-book.

When you see a spot for sketching you may be tempted to walk around the next corner to see if the view is better, and when you get there you will want to go around the next corner, and so on and so on. Eventually you will end up either coming back to the same spot – an hour later – or carrying on around the next corner and ending up sketching

nothing! This may sound ridiculous, but I have fallen into this trap on quite a few occasions and it is very frustrating, especially if you are with your family or sketching friends and they are waiting for you to settle down! The answer is, when something attracts your attention enough to sketch it – sketch it. When you have finished, and if you have enough time, then go around the next corner and do another sketch.

It can be very difficult for a student to look at the scene to be sketched and to know where to start and stop the sketch. Cut a mask out of paper or thin card with an opening of about 15 × 10 cm (6 × 4 in). Make the shape the same proportion as your sketch-book, then your picture will fit nicely on your paper. Hold the mask up at arm's length, close one eye and move your arm backwards and forwards and side to side until the scene is sitting happily in the opening. Then make mental notes of the position of your arm, and key points where the scene hits the inside edge of your mask. You then have the picture designed in front of you (see **fig. 31**). Draw the positions of the main features and then relax your arm, put the mask away and draw your sketch. You can use this method for 'looking' for a scene to paint, by moving the mask around in front of you until

Fig. 29 Information sketch, 18 × 18 cm (7 × 7 in)

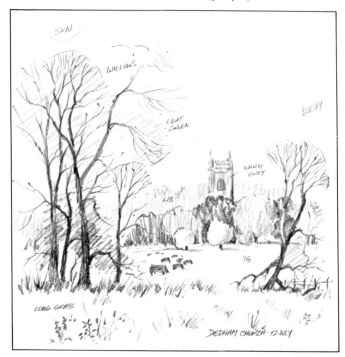

Fig. 30 Atmosphere sketch, 18 × 18 cm (7 × 7 in)

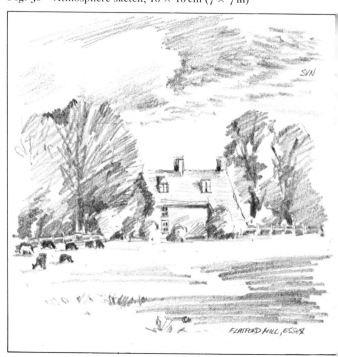

t frames a section of countryside that inspires you to start sketching. If you forget your mask when you are out then make a square with your hands and look through them.

Pencils, naturally, are very important and can be a very personal choice. For sketching, the range from HB to 6B, i.e. hard to soft, light to dark, is more than enough for outdoor work. You will find a pencil or pencils which suit you and your work, but to start with I would recommend an HB pencil for clean line work and a 3B pencil for shading rapid free expression and light and dark tonal work. In **fig. 32** I have shown the tones you can get with seven different pencils, using approximately the same pressure on cartridge drawing paper. Above this, I have used a 3B pencil to show the variation of tone ranging from light to dark.

A good exercise is to get some scrap paper and practise shading with your pencil. You must gain complete control of your pencil – it will make your sketches live. After all, it is the pencil only that creates the image on the paper. I have suggested you use an HB and a 3B pencil. If you want a general purpose one to carry around in your pocket, use a 2B – with practice you can make it do anything. Also in **fig. 32** I have sharpened an HB pencil and a 3B pencil the way you should use them, i.e. with enough lead showing and a long gradual taper to the lead, to enable you to see the pencil point easily when working. The third pencil is sharpened the wrong way.

Whenever you are out in the country sketching or painting, always remember the country code. Close gates after you, don't walk over crops, take litter home and if you want to go on private land always seek permission first. The chances of not getting it are very remote. As far as I know, artists have got a very good name in the country. Let us hope it will always be that way and we can all carry on enjoying and painting from the countryside. (NB When you are out sketching, remember that what you draw you have to understand at home – without the model.)

Fig. 31

Fig. 32

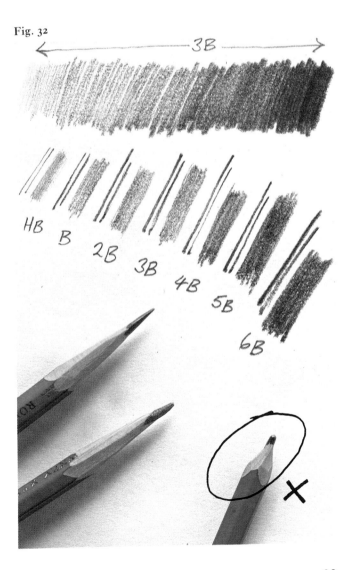

EXERCISE ONE
PENCIL SKETCH
ON LOCATION

I have taken nine subjects for the exercises in this second part of the book and worked them through various stages for you to follow and copy, if you wish. I have explained how the work was done and, most important, I have kept to the *same painting* from the first stage to the finished stage. This is important because it allows you to see the same painting through its stages of development, so that you can compare any stage with what was done earlier. Also, it is important to know the size of the finished painting (not of the reproduction) as this will give you a relative scale to which you can adjust. The actual size is indicated under the finished stage. The close-up illustrations for each exercise are reproduced the same size as I painted them. This gives you the chance to see the actual brush or pencil strokes and the detail that was put in. Finally, I have illustrated the method used for a particular part of the painting that I think you need to see more closely.

I have, quite naturally, painted these subjects in my own style which has evolved over the years. The way I paint in this book is the way I work; I haven't made the paintings work for the book. *But remember, we all have a creative style of our own and this will come out naturally. Once you have mastered the medium, let your own style come to the fore.*

In this first exercise I have tried to recreate a normal sequence of events: going on location in the countryside; preparing pencil sketches (in this case an atmosphere sketch and an information sketch), and then working from the sketch at home. We will work from the sketch, in acrylic colour, in exercise two. I took a photograph of Triggs Lock, near Woking, Surrey, the subject for the sketch, and it is reproduced below – this is the best I could do, other than to have you at my side and looking at the scene!

Now on with our atmosphere sketch and the first important rule to remember when you are out working – make sure you're *comfortable*. If you are not, your work or your body will suffer. You will be copying from these sketches at home and will quite naturally be in a comfortable position, but when you are on location try to be just as comfortable.

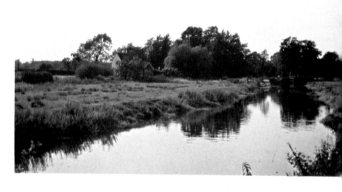

First stage With your 2B pencil draw the main features of the picture on cartridge paper. Try not to rub out any lines that you think may be wrong, but go over them and correct them with your pencil. This helps to build up character and depth in your sketch.

Second stage Now work in the tonal areas of the trees, on both sides of the cottage and the left-hand river bank. If you were out on location you would half-close your eyes to get the tonal values (light against dark). Don't labour this sketch in any way – let your pencil 'scribble' away very happily. Remember, you are trying to create an atmosphere, not an accurate, detailed drawing.

Finished stage Still using your 2B pencil, shade in the reflections using downward strokes of the pencil. Then work freely the nettles on the right-hand foreground bank. Finally, with your putty rubber, take out some horizontal lines in the reflected water areas and add – just a few – horizontal strokes to the water with your pencil.

This method of sharpening a pencil gives a long gradual taper to the lead, enabling you to see the point easily when you are sketching

First stage

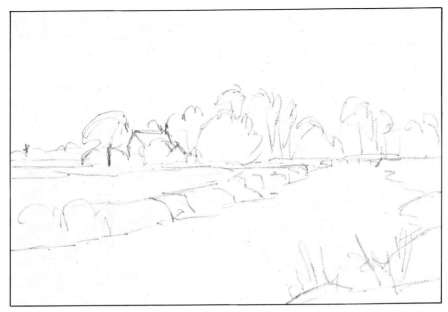

Second stage

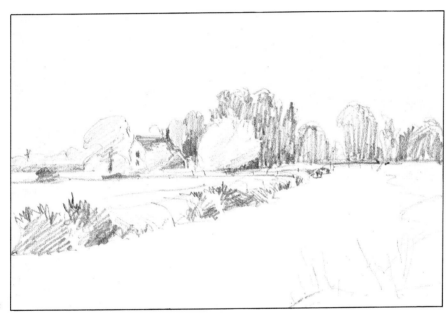

Finished stage
20 × 30 cm
(8 × 12 in)

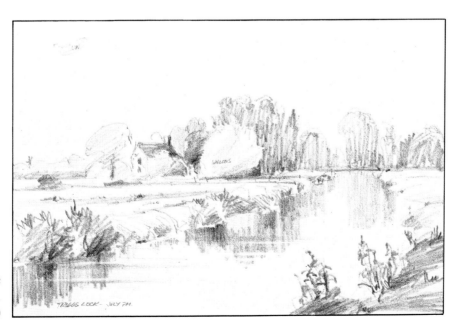

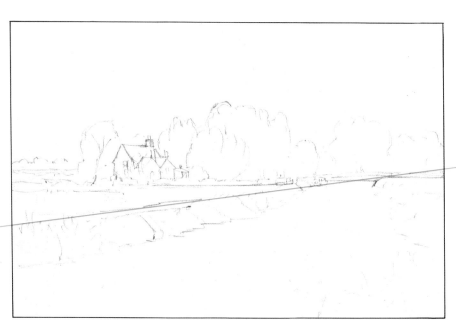

First stage

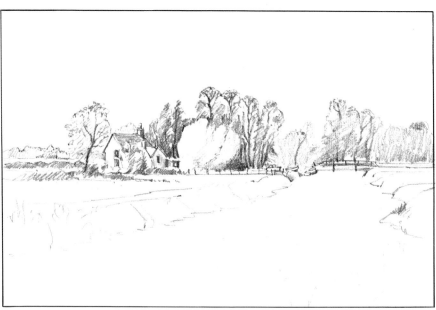

Second stage

Now work at the same subject but make it an information sketch. Remember that the basic difference between the two sketches is that with this one you are seeking information and, therefore, the key factor is observation.

First stage Use your HB pencil and work in the main features: the cottage, the line of middle-distance trees and the river banks.

Second stage Now, with your 2B pencil, start at the left of the cottage, drawing the distant fields, and then work to the right, shading in the trees as you did in the first sketch, but this time put more shape and form into them. Look for the trunks and main branches and draw them. Add more detail with your HB pencil. Put in the fence, the two boats on the bank, the two in the water and the foot-bridge in the distance.

Finished stage With your 2B pencil, working in downward strokes, put in the reflections, draw a few horizontal lines to give movement to the river, and use your putty rubber as you did in the first sketch. Next, draw the plant life on each side of the river bank, putting in more detail than on the atmosphere sketch. It is very useful at this stage to start on a new page and draw some of the plants much larger, especially the close-up ones. This will give you more detail information when you are painting from your sketch at home.

As I said at the beginning of this exercise, the most important thing to do is to be comfortable; now the last thing you must do, which is even more important, is to remember that as soon as you get home, your 'model' has gone and you are left with only your sketch. Therefore, your sketch must contain all the information that you will require to work from. With some people it will be more, with others it will be less. Therefore, your final stage is to look and re-look at your model and then your sketch, and to alter or add anything that you need to make it understandable, which, of course, can mean making written notes.

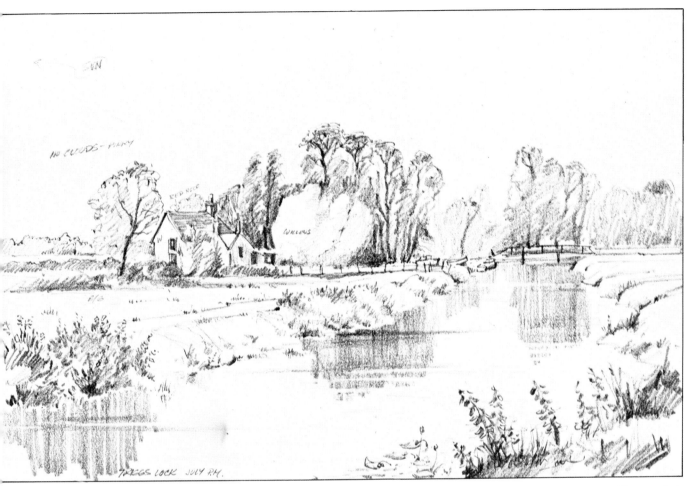

Finished stage 20 × 30 cm (8 × 12 in)

Detail of atmosphere sketch

Detail of information sketch

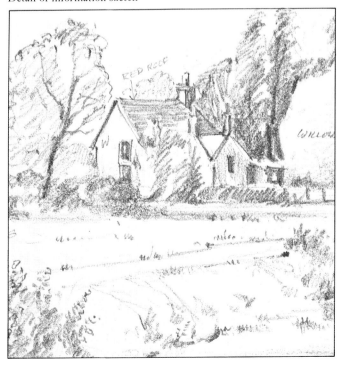

EXERCISE TWO
PAINTING AT HOME FROM PENCIL SKETCH
IN ACRYLIC COLOUR

This is where the painting starts! Make sure that you feel confident enough to start this painting. If you lack only a little confidence then carry on and I will help you through it; if you are worried then work at some of the earlier exercises again before tackling this one. If you prefer to try watercolour or another medium then start with another exercise. *In this exercise and all the others that follow, it is important to know that when you are mixing colours, the colour you should mix into is the one I mention first:* add the other colours (in smaller amounts) to this one. The first colour is usually the one representing the main colour. White is usually last unless, of course, it is the main colour. Where there is a set of colours shown in acrylic or oil colour at the beginning of the exercises (as on this page) they comprise only the main primary colours or mixed colours used for particular areas, in that particular exercise. Because you will have sketched this picture twice in the last exercise, you will be familiar with your first painting subject. This will help you to relax more. Good luck!

This painting was done on an acrylic-primed canvas.

First stage Draw the picture with your HB pencil, working the main areas as you did in the sketches. Don't try to draw the trees in detail or the banks of the river – leave this for your paintbrush. Mix Coeruleum Blue, Crim-

SKY / WATER —
COERULEUM BLUE
CRIMSON
WHITE
CADMIUM YELLOW

DARK TREES —
ULTRAMARINE
CRIMSON
BRIGHT GREEN
WHITE

GRASS —
CADMIUM YELLOW
CRIMSON
BRIGHT GREEN
ULTRAMARINE
WHITE

son and White. With your size No. 12 nylon brush, start at the top of the canvas, working from left to right, and paint down to the horizon. Add more Crimson and White and Cadmium Yellow as you work behind the drawing of the trees. Paint the river area with the same colours.

Second stage Start with the distant trees on the left of the cottage. Use your size No. 2 nylon brush and a mix of Ultramarine, a little Crimson, Cadmium Yellow and White. Now paint the field underneath these trees, using Cadmium Yellow, Crimson and White. Paint the hedge running in front of the field and up to the cottage, still using your size No. 2 nylon brush, with a strong mix of Ultramarine, Crimson and Cadmium Yellow. Underneath this hedge, paint the start of the field, using Bright Green, Cadmium Yellow, Ultramarine and just a touch of Crimson and White. Next paint the cottage roof, using Cadmium Red, Cadmium Yellow, a little Bright Green, Ultramarine and White. Paint the wall of the cottage with White, Cadmium Yellow and Crimson. For the dark area of the wall use Crimson and Ultramarine. The row of trees behind the cottage and continuing to the right are next, but leave out the willows. Use your size No. 4 nylon brush and a mixture of Ultramarine, Crimson, Bright Green and White. Change the relative strength of the colours in the mixture to vary the colours of the trees, and use more White for the distant trees. Work the paint at the top of the trees thinner to let the sky show through. Don't go for detail, only shape and form. Now paint the willow trees with the same brush, mixing Coeruleum Blue with Bright Green, Crimson and White. Add the shadows to the willows by using less White. Finally, using the colours of the row of trees behind the cottage and your size No. 4 brush, put in the tree on the left of the cottage. Use the dry brush technique for this tree. This simply means that you dry out your brush more than usual, load it with paint, work the excess paint off on your palette, and drag the brush over the painting surface.

Third stage With your size No. 2 nylon brush and the same colours as the cottage roof, but a little darker, paint the front of the cottage. For the shed on the right, use Ultramarine, Crimson, Raw Umber and a little White. Paint the trees in front of the cottage with your size No. 4

First stage

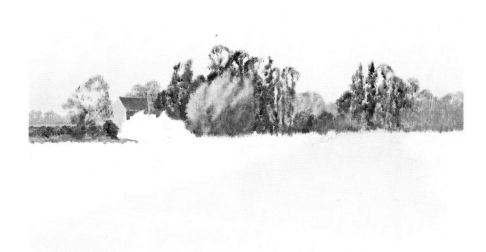

Second stage

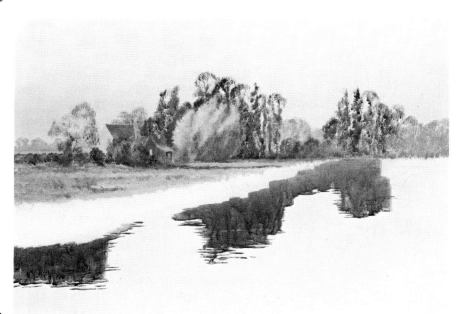

Third stage

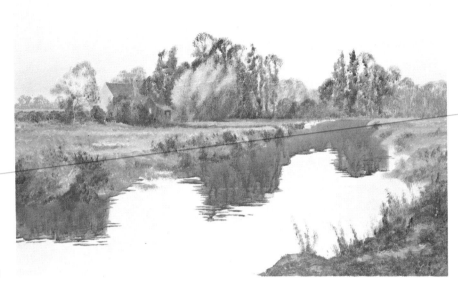

Fourth stage

nylon brush and a mix of Bright Green, Ultramarine, Crimson and White. Next, using your size No. 2 nylon brush and a varying mix of Cadmium Yellow, Crimson, Bright Green and White, paint the field underneath the middle-distant trees. Now use your size No. 4 nylon brush to paint the field down to the path on the river bank in the foreground. Make the further field under the trees darker. Paint the path with your size No. 4 nylon brush and a mixture of Cadmium Yellow, Crimson and White. Finally, paint the reflections in the water, with your size No. 6 nylon brush. Mix Ultramarine, Crimson, Bright Green and a touch of Burnt Umber with lots of water and apply the paint in washes with downward strokes (see pp. 24–25 on water). Finish with horizontal strokes to break up the reflections. As the watery paint builds up into 'puddles' on your canvas, dry your brush out and blot them up. Apply further washes of paint when the preceding one is dry. I used four washes on this painting.

Fourth stage The left-hand river bank is next. When you put this in try to let the brush form some of the plant growth. You will be pleasantly surprised at what brush strokes can create without being laboured. Work the brush in different directions; push it against the natural flow of the bristles – stabbing and twisting movements of the bristles will all help to create different effects. When you mix the colours, don't just make one colour – mix them to give varying colours and tones as you work along the bank. Use your size No. 4 nylon brush and Bright Green, Ultramarine, Crimson, Raw Umber, Cadmium Yellow and White. Work from the bridge to the foreground. Now, with the same colours you used for the left-hand field plus Ultramarine for dark areas, paint the right-hand field and the bank with your size No. 4 nylon brush. Paint the dry mud first, using Cadmium Yellow, Crimson, Burnt Umber and White. Use your size No. 2 nylon brush to work in the suggestion of nettles and plants in the foreground, dragging the brush up into the water area.

Finished stage Use your size No. 6 sable brush to start to put in detail work. Add more work to the trunks and branches of trees using your 'tree colours' and, with the same colours, put in the cottage windows. Then, using White, Coeruleum Blue and a touch of Crimson, paint the

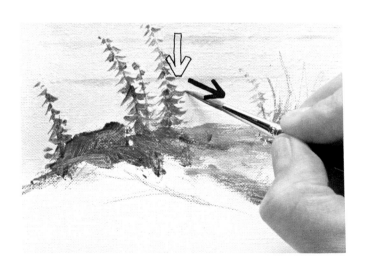

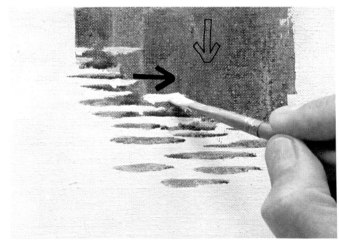

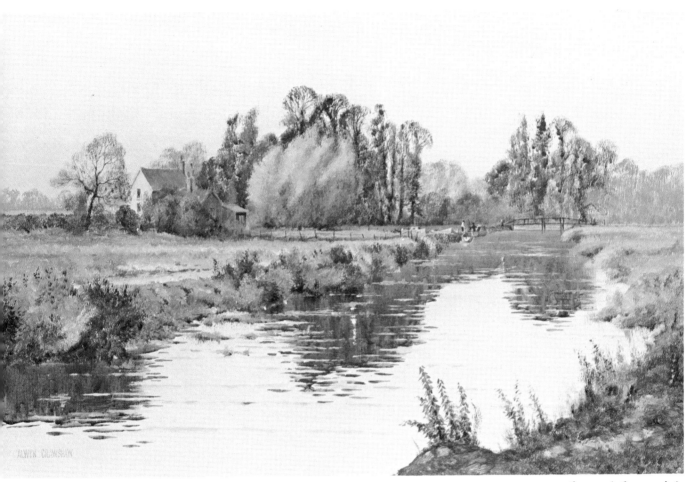

Finished stage 41 × 61 cm (16 × 24 in)

light water behind the bridge with horizontal strokes. With the same brush, paint the bridge itself. Use Cadmium Yellow and White for the boats on the bank, and Ultramarine, Crimson and Cadmium Yellow for the ones on the river. Now work on the bank, using dark colours to bring out leaf shapes over the light areas, and light colours over dark areas. Using White, Coeruleum Blue and Crimson, drag your brush across the middle-distance of the river to form ripples. With your No. 2 nylon brush and the same colours work downwards, painting into the reflections. With the same colours used for the reflections, paint some dark horizontal lines into the light areas, breaking up the reflections. Put in some weeds on the left-hand side of the river, using Bright Green, Cadmium Yellow, Crimson and White. Now using your size No. 6 sable brush, put in detail on the nettles. Put the leaves in with single brush strokes, working the brush outwards from the stems. Now put in the 'vertical' highlight on the water and the two men by the boats. These are just single brush strokes using light and dark colours. Finally, look at the painting with a 'fresh eye' and then add highlights and dark accents where you feel they are necessary to finish *your* painting.

NOTES ON WATERCOLOUR SKETCHING OUT-OF-DOORS

Watercolour sketching can be assumed to be an extension of a pencil sketch. In some cases this is quite true. You can work a pencil drawing in very much the same way as a pencil sketch – with perhaps a little less shading – and then work watercolour over it for colour reference. I prefer to think of watercolour sketching as producing a watercolour painting in its own right. It has its own problems to cope with of course, as any other medium, but if things do start to go wrong there are ways of overcoming them (more about this later) – even if in the extreme it means starting again (which I have had to do quite often)! When you do go out to do some watercolour sketching be definite in your conviction that you will create a true watercolour painting.

You will need your box of paints, brushes, sketch-book or drawing board and paper, pencil, putty rubber, water holder, viewing mask (as in pencil sketching), sponge and stool, although a stool is not always necessary. To help to carry all this you need a holder. This can be anything from a plastic carrier bag to a purpose-made bag.

Many years ago my daughter made me one to my specification from a leg of an old pair of corduroy trousers, even using the existing pockets for holding my water container (a plastic medicine bottle) and my water jar (an old tobacco tin). These containers were chosen simply because they fit into the pockets. The leg was folded in two which gives two large pockets. One takes my sketch-book and the other my watercolour box and a case with everything but the kitchen sink in it. This case was bought for fishing floats and hooks but has always lived in my sketching bag.

The contents are: sable brushes, pencils, putty rubber, sponge, rubber bands for holding down sketch-pad pages when it's windy, a knife and, finally, sticking plasters and aspirin – you never know what will happen and you can be a long way from civilization. This is all illustrated in **fig. 33**, and in **fig. 34** you can see how compact it is when all is packed away. This is my sketching kit; in fact, it is a miniature portable watercolour and drawing studio. If I am going on a special trip, all I carry in addition to this is a drawing board to take large sheets of watercolour paper, a stool and my camera. You may find you need an easel; if you prefer to use one there are lightweight portable types on the market. I find that resting a board or sketch-book on my knees is satisfactory and comfortable.

I went to Henley-on-Thames to paint the Regatta last summer. This was to be a watercolour information sketch for a 51 × 102 cm (20 × 40 in) painting in acrylic colours to be done in the studio. **Fig. 35** shows me working (that

These information sketches make use of two watercolour techniques. Above, I have used white paint for the figures to make them opaque, so I was able to put in the figures after I had painted the field. Below, I have added black felt-tip pen to bring out the detail. They are both 14 × 18 cm (5½ × 7 in)

isn't my chair) and you can see the simplicity of the equipment I use for working out-of-doors. **Fig. 36** shows the view that I had of the Regatta and **fig. 37** is the finished watercolour sketch. If you look at the photograph and then the painting you can see how my eye has brought the distance much nearer.

Don't try to rush a watercolour sketch. Look at the scene first, analyse it in your mind, decide how you intend to paint it and then start. If it goes completely wrong and you

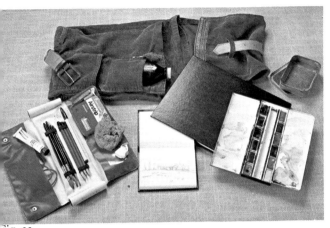

Fig. 33

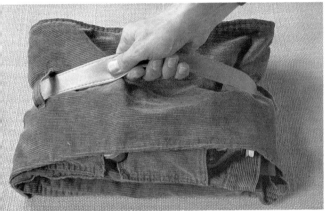

Fig. 34

My sketching gear (top), and folded away in a holdall made for me by my daughter

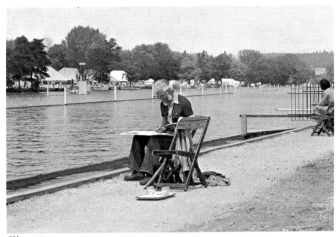

Fig. 35

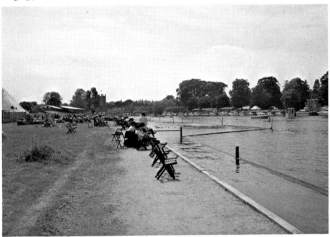

Fig. 36

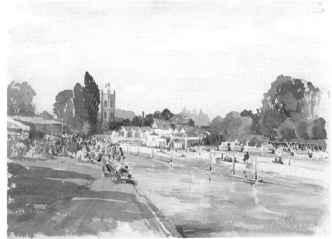

Fig. 37 *Henley Royal Regatta*, 38 × 51 cm (15 × 20 in). Watercolour information sketch

have got time to start again, then do so. If not, here are three ways to salvage your work. In your kit carry a pen and some black waterproof ink, or a black ball-point pen, a black felt-tip pen, or even a fountain pen filled with black ink, and a tube of White Designers' Gouache colour.

The first method is to leave your painting for about half an hour (time permitting) and then come back and look at it again with a fresh eye. It could look a lot better than you originally thought. If you feel you could get still more out of it, then go over your work with a pencil as though you were doing a pencil sketch. This method can sometimes revive your painting and give life back to a very flat, uninspiring watercolour.

The second way, and one that is a technique in its own right, is to add pen to the painting. Use the pen to draw over the unsuccessful watercolour and make a 'pen and wash drawing' of it. The colour will show through and the result could be a very pleasing sketch.

The third way is to add White to your colours, as this will make them opaque and enable you to overpaint your troubled areas. This again is a technique in its own right, called body colour painting. You could finish the painting in this way and produce a perfect sketch. As you can see, all is not lost when your watercolour goes astray. If you want to stick to pure watercolour be careful that you treat these ways only as emergency escape hatches, not as easy ways out of a problem.

Important – don't make notes on a watercolour sketch as you might decide to use it as a finished painting. Make your notes separately, on the back (if thick paper) or on a separate piece of paper.

EXERCISE THREE
WATERCOLOUR SKETCH
ON LOCATION

For this exercise I chose to paint Salisbury Cathedral as an information sketch to use for a larger acrylic painting that will be done in the next exercise. I set out to paint this as a normal watercolour without the extra aids of pen and ink or White paint. As I said in the previous section, a 'pure' watercolour sketch can always be used as a 'finished' water-colour painting – hence the reason why no information comments in pencil should be written on a sketch. This doesn't mean that a pen and ink sketch can't be used as a 'finished' painting; on the contrary, it would be just as finished as a watercolour, but it would not be a pure water-colour. I find it more challenging to go for a watercolour first, because if it doesn't come off I can then add pen and ink or White.

As in the first exercise, I took a photograph of the subject to give you the chance to see what licence – if any – I took with my painting as against the real thing. Incidentally, if when you are working on this watercolour you 'lose control' of it, don't throw it away but use pen and ink, pencil or White paint to try to bring it round. You could be very pleasantly surprised at the result. Form a habit now of never throwing a sketch away, no matter how bad you think it is. Sketches will always have something to say, especially if they were done from nature. Keep them to refer back to, even if it's only to see how you have improved! I have said this earlier, but it is important enough to repeat.

First stage Draw the picture with your HB pencil. This sketch was done on GREENS RWS 140lb NOT SURFACE water-colour paper pinned to a drawing board. The paper was not stretched first. Now damp the sky area with a sponge or large brush but do not go over the cathedral steeple or into the trees. Load your size No. 10 sable brush with a very watery mixture of Coeruleum Blue and a touch of Crimson Alizarin. Apply this wash to the damp paper, working the brush in broad strokes, and add a touch of Yellow Ochre to the mix as you get further down the sky towards the horizon. Don't paint over the steeple.

Second stage Using your size No. 6 sable brush and a mixture of Yellow Ochre and Crimson Alizarin, paint the steeple and stonework of the cathedral. The sun is coming from the right-hand side of the picture, but the shadows on the cathedral will not be put in until a later stage. Next paint the roof of the cathedral, using a wash of Coeruleum Blue and Cadmium Yellow Pale. Now, still with your size No. 6 sable brush, mix Cadmium Yellow Pale, Crimson

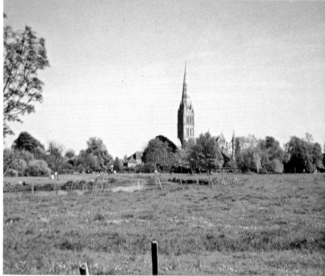
A portion of the photograph I took of Salisbury Cathedral

Alizarin and a touch of Hooker's Green No. 1 and paint the roofs of the buildings. With a watery Yellow Ochre, paint the buildings themselves. Now, with your size No. 10 sable brush and a wash of Hooker's Green No. 1, Payne's Grey, Crimson Alizarin and a touch of Cadmium Yellow Pale, paint the row of trees from left to right – vary the colours and tones of the paints. Use only one wash for these trees at this stage, except for the dark trees in front of the cathedral. This will give you the darkest tonal area of the painting.

Third stage Before you start this stage, look carefully at the shapes of the trees that will be defined by adding the next wash. When you start, don't try to copy exactly or you will lose spontaneity and the freedom of a simple wash. Just remember that you are painting trees and the forms and shapes they make. Use your size No. 6 sable brush and the same colours that you used for the first wash on the trees, but stronger. Use French Ultramarine in place of Payne's Grey. Using the same brush and the same colours, put in the windows and shadows on the buildings behind. Also paint the wall in front of the cathedral, to the right of the dark trees, using a wash of Crimson Alizarin and Yellow Ochre. Finally, paint the field on the left-hand bank of the river, using your size No. 6 sable brush with a wash of Cadmium Yellow Pale, Hooker's Green No. 1 and Crimson Alizarin. Leave small areas of white paper so you can work people in later.

First stage

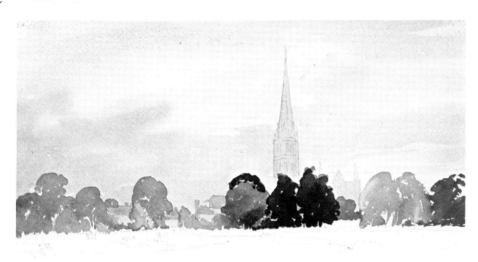

Second stage

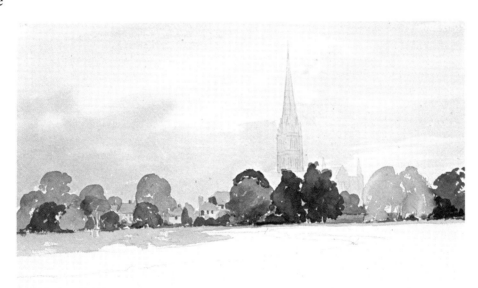

Third stage

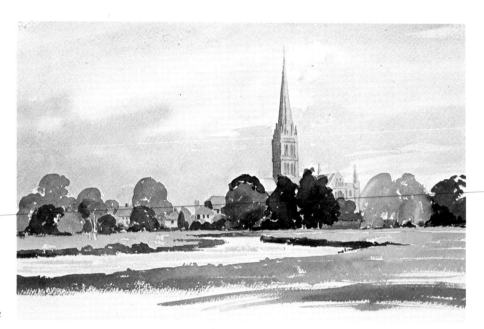

Fourth stage

Fourth stage Now add form and dimension to the cathedral steeple. Use your size No. 6 sable brush and a mix of French Ultramarine, Crimson Alizarin and a touch of Yellow Ochre to paint the shadow side of the steeple. Then, with the same brush and colour, suggest the windows and moulding on the remainder of the cathedral. Don't be too fussy with this detail work. If it is too detailed it will jump forward and not stay in its correct place – in the middle-distance! Now, with the same brush, work the river banks, using the same colours as the field but adding Payne's Grey. The river is fast moving and has plenty of ripples. Using your size No. 6 sable brush, mix Coeruleum Blue and Crimson Alizarin and paint the water, using horizontal brush strokes and leaving plenty of white paper showing. With your size No. 10 sable brush, plenty of colour and water and very free brush strokes, paint the right-hand field up to the foreground. Use Cadmium Yellow Pale, Crimson Alizarin, Hooker's Green No. 1 and a touch of French Ultramarine.

Finished stage In this sketch I put in just a suggestion of a reflection of the steeple as I felt that the watercolour could do with it, but I chose to leave it out of the acrylic painting in the next exercise. To put in the reflection use your size No. 6 sable brush and the colours that you used for the original steeple. When you have painted it, and it is still wet, take out the bottom of the reflection with blotting paper. Then, using the colours of the river bank, paint the reflections of the left-hand bank, with horizontal brush strokes as the water is moving fast and rippling. Use your size No. 6 sable brush to paint the figures in the field. Use dark colours and still leave showing some white areas from when you painted the field. Use any colours you like for the people. Put in any more detail you feel necessary on the cathedral and put in dark accents under the trees. Finally, with your size No. 10 sable brush, paint over the foreground field with definite, unlaboured brush strokes, using the same colours as before, but much stronger.

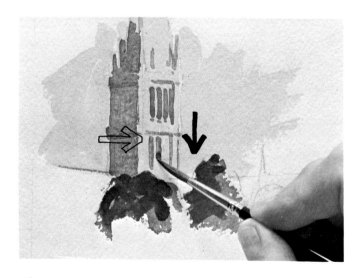

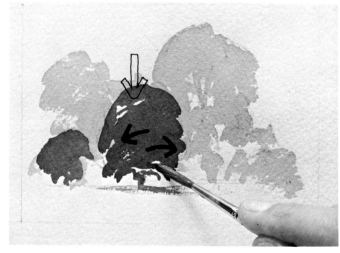

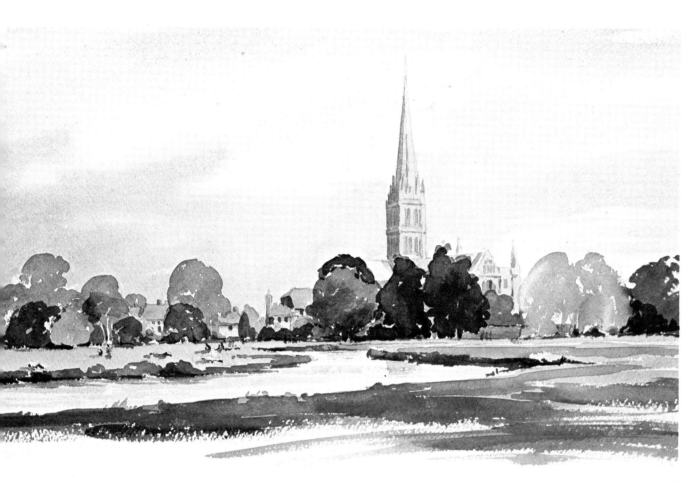

Finished stage

27 × 41 cm (10½ × 16 in)

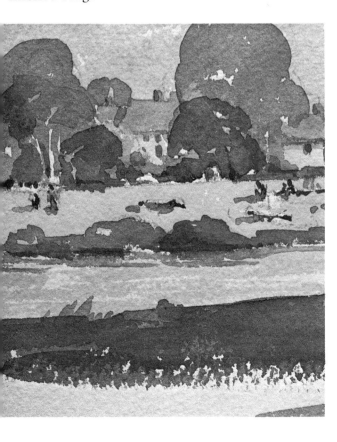

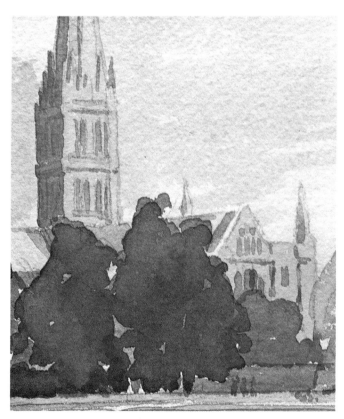

47

EXERCISE FOUR
PAINTING AT HOME
FROM WATERCOLOUR SKETCH
IN ACRYLIC COLOUR

Working at home from a sketch drawn on location gives you the advantage of being familiar with the subject. If it is a coloured sketch, as is this one of Salisbury Cathedral, then you will have totally experienced and recorded the subject. When you do it again in the comfort of your own home, time will be on your side to rethink certain passages of the painting that could be worked differently.

When you painted the banks of the river in the painting in exercise two, I told you how you could get varying visual effects of plants, grass, etc by working your brush in different ways. When I paint a landscape with acrylic colours I have my very special 'tree brushes' that I use to help me to get natural looking effects. These nylon brushes have been used for many years and have gradually formed the ungainly shapes that they now have (see **fig. 38**). When you are working the trees and grass on this painting and if you have an old or what you think is a worn out brush try using it. Experiment on paper first. This painting was done on an acrylic-primed canvas.

First stage Draw the main areas with an HB pencil. Using your size No. 12 nylon brush and a mix of Ultramarine, Crimson, a touch of Raw Umber and White, paint the sky. Start at the top left and work across and down. Vary the tones as you work and add Raw Sienna to your mix as you move further down the canvas. Make the sky on the right-hand side of the steeple darker than on the left-hand side. Then, with plenty of White, Raw Sienna, Crimson and a touch of Cadmium Yellow, work the light area to the left of the steeple. Let the sky go over the drawing of the trees. Use less White where you want the sky to get darker and more White where you want it to get lighter.

Second stage Start at the top of the steeple and work down the shadow side with your size No. 6 sable brush then work on with your size No. 4 nylon brush. Use Raw Sienna, Ultramarine, Crimson and White. Next paint the light side in the same way, using Raw Sienna, Cadmium Yellow, Crimson and White. With the same colours paint the end of the cathedral. Next, mix Coeruleum Blue Bright Green and White, and with your size No. 2 nylon brush, paint both roofs of the cathedral. With your size No. 4 nylon brush, paint the roofs of the buildings using Cadmium Red, Cadmium Yellow and White. Next paint the walls of the buildings, using the same colours as you used for the light side of the cathedral. With your size No. 6 sable brush and the colours you used for the dark side of the steeple, put in the windows and shadows of the steeple and buildings.

Third stage Start by putting in the distant trees to the left of the cathedral. Use your size No. 4 nylon brush with

SKY—
ULTRAMARINE
CRIMSON
RAW UMBER
RAW SIENNA
WHITE
CADMIUM YELLOW

STEEPLE—
RAW SIENNA
ULTRAMARINE
CRIMSON
CADMIUM YELLOW
WHITE

TREES—
ULTRAMARINE
CRIMSON
BRIGHT GREEN
RAW UMBER
CADMIUM YELLOW
WHITE

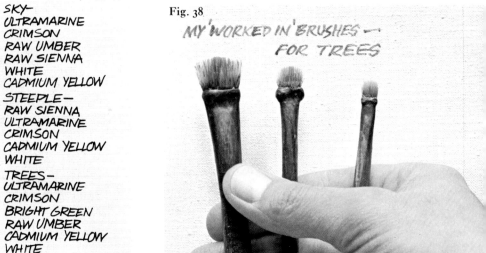

Fig. 38

MY 'WORKED IN' BRUSHES — FOR TREES

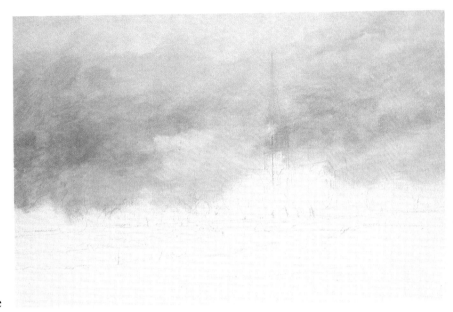

First stage

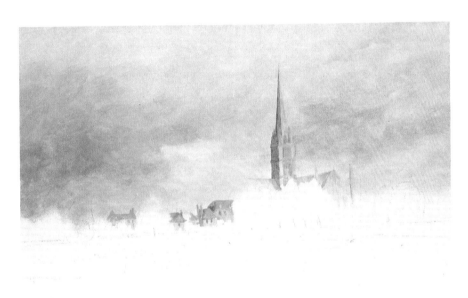

Second stage

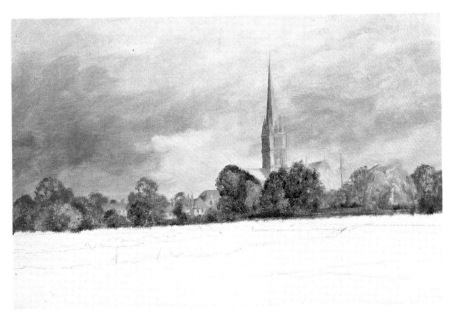

Third stage

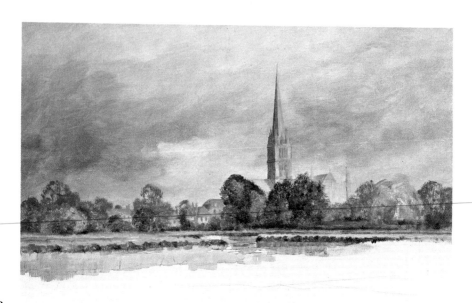

Fourth stage

Ultramarine, Crimson, Bright Green and White. Add Cadmium Yellow to these colours for the nearer trees. Work from left to right. Change the consistency of these colours to give colour variation to the trees. When you get to the darker trees in front of the cathedral use more paint. Add Raw Umber and use less White for the dark areas. Work each tree as your own 'personal tree'; don't try to copy my trees exactly or, for that matter, the ones in the watercolour sketch. Paint the reddish-brown wall in front of the cathedral with Cadmium Yellow, Crimson, Ultramarine and White. Use your size No. 4 nylon brush and paint the wall behind and to the right of the dark trees you have just done and to the right and under the willow trees. Finally, paint the willows, using White, Cadmium Yellow, Bright Green and a little Crimson. Work the brush strokes outwards from the centre of the tree, in the direction in which the leaves are falling.

Fourth stage Start with the field on the left-hand bank. Use your size No. 4 nylon brush and a mix of Bright Green, Raw Umber, Cadmium Yellow, a little Crimson and White. Remember to vary these colours as you paint the field.

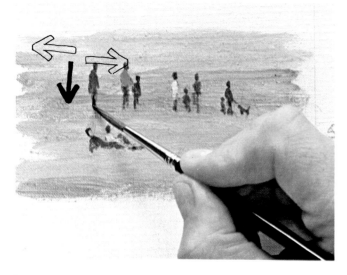

Next paint the bank itself, using the same brush, with Ultramarine, Bright Green, Crimson and a little Raw Umber. Add White to lighten areas. Now paint the river, using a watercolour wash technique as you did in the second exercise. Use your size No. 6 nylon brush and a wash of Ultramarine, Crimson and a touch of Bright Green. Now paint the field to the right of the river and the bank, using the same colours as you used for the first field.

Finished stage Paint the foreground field next, starting at the top and working down the canvas. Use your size No. 4 nylon brush and drag a mix of Bright Green, Cadmium Yellow, Crimson, Raw Umber and White down the canvas. For the darker areas near the foreground add Ultramarine. Work the brush in up and down strokes to give a grass effect, letting the brush go up into the last bit of grass you have painted. Use the *edge* of the brush, working in upward strokes, to paint the nettles, thistles and plants (use the light against dark principle here). This will help to make the grass look long and 'summery'. Next, with your size No. 2 nylon brush, put in some buttercups and dandelions with Cadmium Yellow, a touch of Crimson and White. With your size No. 6 sable brush, paint the main tree trunks in the middle-distance. Now put in the people. Use your size No. 6 sable brush and paint them in one stroke, starting at the head and dragging the brush down almost as if you were drawing with a pencil. Choose your own colours, but remember that light against dark or dark against light will help to show up the figures. Now put in some more detail work on the cathedral, using your size No. 6 sable brush. Keep the work light in tone and 'free' or it will jump forward too much. Using the same colours as before but darker, tone down the cathedral roof. Next, with your size No. 2 nylon brush and White, Coeruleum Blue and a touch of Crimson, paint the highlights on the river with horizontal strokes. Put in the fence with your size No. 6 sable brush and a mix of Burnt Umber, Bright Green and Ultramarine. Finally, look over the painting and add highlights and dark accents where you feel they are necessary.

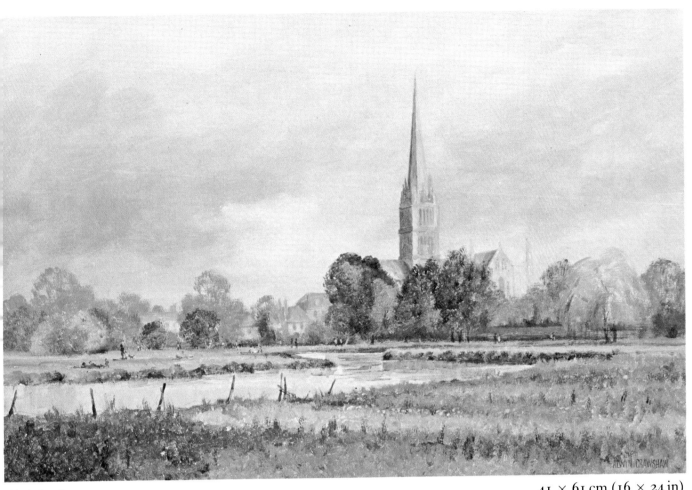

Finished stage

41 × 61 cm (16 × 24 in)

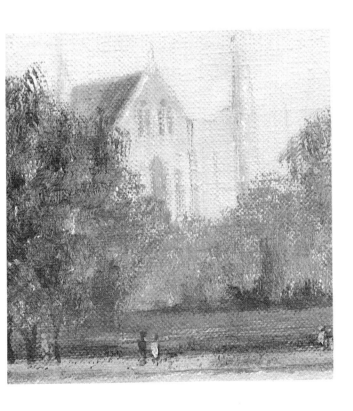

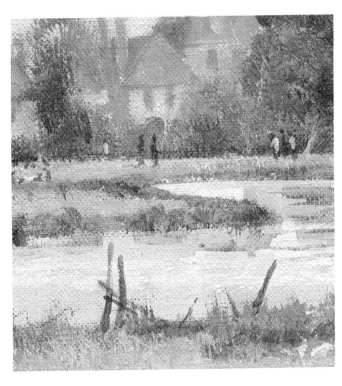

I think that as artists we all want to have a go at mountains at some time or another. They can excite you by their sheer size and majesty, by their loneliness, or by the contrast of light and dark. One thing I like to see in a mountain picture is something to show the scale. In the picture you are now going to paint, the scale is shown by the village at the foot of the mountains.

For this oil painting I used a gel medium to dry the paint more quickly on the canvas. I mixed this with my colours as I went along. The painting was completed in one sitting without any acute problems of the paint being too wet to work over – but I worked as directly as I could to avoid a lot of overpainting (this is my natural style). I used only four colours and White for this picture. One of them is Crimson Alizarin, a colour you should beware of as it is very strong. Only touch your brush into it when you are mixing. Some artists mix their oil colours on the palette with a palette knife first, then use their brush for painting. There is nothing wrong with this; after all it is the end result on the canvas that matters, not how we get there. I mix my paints with a brush and work on the canvas with the same brush. I use a 50/50 mix of turpentine and linseed oil as my medium for mixing with the paint, and turpentine for cleaning my brushes.

First stage Use your HB pencil to draw the picture. With your size No. 10 brush mix White, Cobalt Blue, Yellow Ochre and a touch of Crimson Alizarin. Start at the top of the sky and work down, using less White in the dark

SKY—
TITANIUM WHITE
COBALT BLUE
YELLOW OCHRE
CRIMSON ALIZARIN

SHADOW AREAS—
COBALT BLUE
YELLOW OCHRE
VIRIDIAN
TITANIUM WHITE

SUNLIT AREAS—
YELLOW OCHRE
VIRIDIAN
CRIMSON ALIZARIN
TITANIUM WHITE

shadow underneath the cloud. Work the darker paint back into the light area to give it a soft cloud effect. Then paint the middle mountain as the sky will be painted over this. Use Cobalt Blue, Crimson Alizarin and touches of Yellow Ochre and White. When you paint this mountain, as in all the other mountains to come, work your brush strokes to follow the contours and the 'fall' of the mountain.

Second stage Using the light cloud colours, paint the clouds underneath your first big cloud and work the paint over the parts of the mountain you have just finished. Leave some hard edges to show its form. Then work some dark cloud colour back into the shadow area of the top cloud again and drag the brush down into the light cloud underneath to show the rain effect. Still using your size No. 10 brush, paint the mountain below, which is in the sun's shadow, and the one just behind the village. Use Cobalt Blue, Yellow Ochre, a little Viridian and White. When you work on the left side, use more White with your colours as the sun is catching the mountain. Work dark and light areas as you paint the mountain and remember to let the brush follow the contours of the mountain. On the lower mountain area, where it is in shadow, use your colours a little darker as it is nearer to you.

Third stage Use your size No. 8 brush throughout this stage and a varying mixture of Yellow Ochre, Crimson Alizarin, Viridian and plenty of White for the sunlit areas, and a mixture of Cobalt Blue, Crimson Alizarin, Yellow Ochre and a little White for the shadow areas. It is impossible to explain this stage in brush by brush detail, but if you follow these simple guidelines you will manage very well. First, don't try to copy my brush strokes exactly; let your natural brush strokes shape the contours of the mountains. Second, paint the shadow shapes first and then work in the light areas, up to and blending into the shadow areas. Third, work on each mountain or part of a mountain separately. Finally, make sure that the left-hand foreground mountain is dark as it is in strong shadow.

Fourth stage With your size No. 4 brush, paint the trees behind the houses. The painting is in spring and most of the trees are without leaves. Paint them thinly at this stage (not too much paint) and work dark and light trees. For the dark trees use Cobalt Blue, Crimson Alizarin and Yellow Ochre; for the light ones use Yellow Ochre, Crim-

First stage

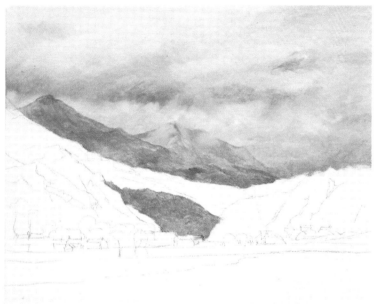

Second stage

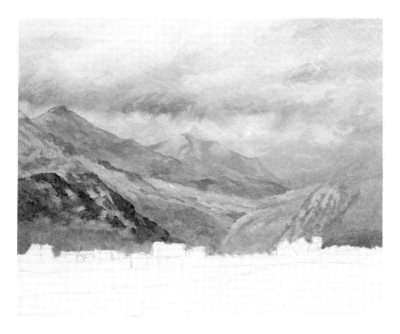

Third stage

53

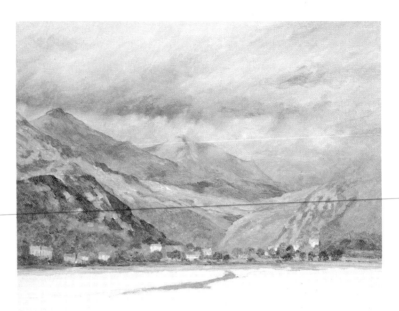

Fourth stage

son Alizarin and White. Use downward strokes of your brush and work from left to right. Work the trees up the hillside under the dark mountain on left. Using the same brush, with Cobalt Blue, a touch of Crimson Alizarin and some White, paint the roofs of the houses. For the walls of the houses, mix White with a touch of Yellow Ochre. You can ad-lib the houses and put down more or less what I have done. You can suggest the windows by using your brush on its edge. Paint the roof tops on the left darker as they are in the shadow of the mountain. Still using your size No. 4 brush and the tree colours, but darker, paint the trees in front and 'underneath' the houses. When you come to the middle, paint the furthest field that you can see, using White, Yellow Ochre and Viridian. Then continue painting the trees over the top of this field. Now mix up a dark colour with Cobalt Blue, Crimson Alizarin and Yellow Ochre and, with the same brush, start at the left of the village and drag the brush horizontally underneath and slightly up into the trees and houses you have painted. This gives a visual base for the village and it also creates that misty area in a painting where a lot is happening but you can't show any definition or detail. This paint will mix with the wet paint of the houses and trees, which helps to create the effect. With a clean size No. 4 brush paint the green field across the picture, using horizontal strokes and a mix of Viridian, Yellow Ochre and White. Finally, with the same colours, paint the path leading to the village.

Finished stage With your size No. 6 sable brush, put in the three trees on the front edge of the green field. Then, with your size No. 4 brush, paint the wall across the front of that field and add the other wall behind that one on the right of the picture. For these walls use Cobalt Blue, Crimson Alizarin and Yellow Ochre. Next, with your size No. 8 bristle brush and a mix of White, Yellow Ochre, Crimson Alizarin and a touch of Viridian, paint the middle fields. Now paint the area in shadow, using Cobalt Blue, Crimson Alizarin, Yellow Ochre and just a touch of White. Paint the path with the same colours, but lighter. If there are any parts of the painting you want to alter, wipe the paint off with a clean rag, or wait for the paint to dry first and paint over the top.

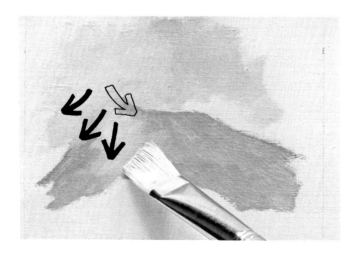

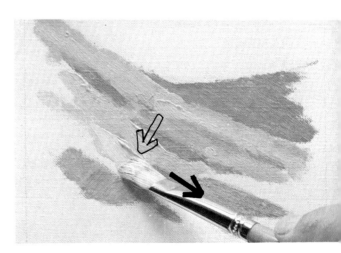

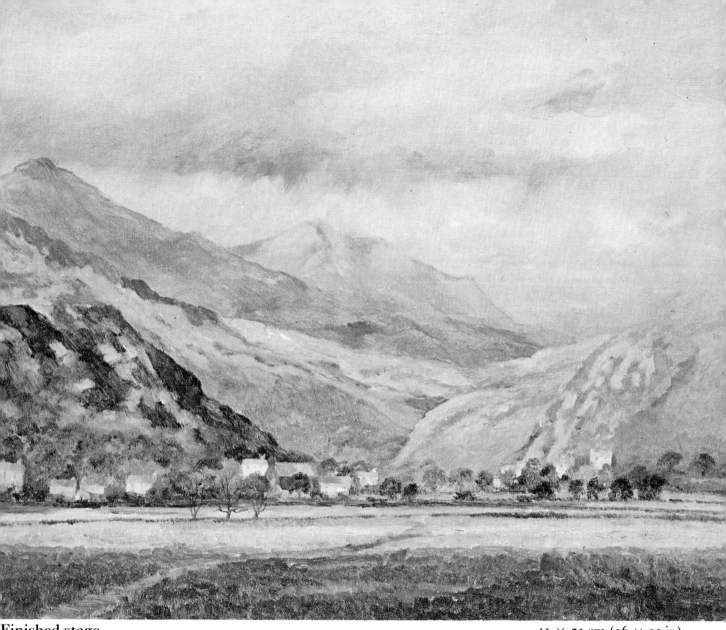

Finished stage

41 × 51 cm (16 × 20 in)

First stage

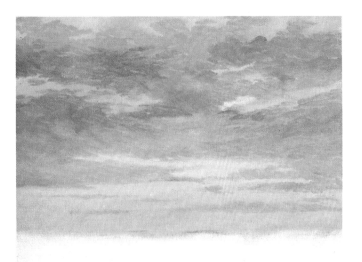

Second stage

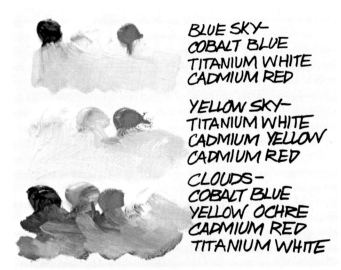

BLUE SKY—
COBALT BLUE
TITANIUM WHITE
CADMIUM RED

YELLOW SKY—
TITANIUM WHITE
CADMIUM YELLOW
CADMIUM RED

CLOUDS—
COBALT BLUE
YELLOW OCHRE
CADMIUM RED
TITANIUM WHITE

EXERCISE SIX
SKY
IN OIL COLOUR

I believe that an evening sky must excite all landscape artists but, unfortunately, a strong, full-blooded sunset is so often referred to as 'chocolate boxy'. I have thought about this over the years and come to the conclusion that some of nature's most startling effects cannot be faithfully reproduced as paintings, as they look 'unreal', but if we were out with nature and saw these effects we would all accept and admire them. For this sky exercise I have selected a sunset, but what I call a gentle one. As in the previous exercise, I painted this in one sitting on canvas and used a gel medium to speed up the drying.

First stage Draw the main cloud areas with your HB pencil. Use your size No. 10 bristle brush and a mix of Cobalt Blue, White and a little touch of Cadmium Red to paint the areas of blue sky. Wash your brush out in turpentine and then mix White, Cadmium Yellow and Cadmium Red for the sunlit cloud areas. Paint these areas, adding more Cadmium Red as you get nearer to the horizon.

Second stage Now put in the cloud formations, starting at the top. Mix Cobalt Blue, Yellow Ochre, Cadmium Red and White and use your size No. 10 bristle brush. Work the brush strokes outwards on both sides from the centre and let the brush strokes follow the shape of the clouds. Work the clouds over the existing blue sky. As you get nearer to the yellow sunlit sky add more Cadmium Yellow and Cadmium Red to make the clouds pinker. Using the same colours, but adding much more White, paint the horizontal clouds over the yellow/pink sky. Be very gentle with your brush strokes as you will be going over wet paint.

Finished stage Use your size No. 6 bristle brush for putting in the highlights on the clouds. Start at the top where they are much whiter, using White and Cadmium Yellow. When you get to the yellow part of the sky, add a little Cadmium Red to your mix to make it more orange and use the paint much thicker. Add these highlights to the edges of the clouds. Now paint the silhouettes of the houses and trees – they will give scale to the sky. Use your size No. 6 bristle brush and Cobalt Blue, Cadmium Red and Yellow Ochre. Paint this area very dark. When you come underneath the large break in the clouds, add more Yellow Ochre and Cadmium Red to your colour. Finally, with your size No. 6 sable brush, add the chimney pots and television aerials.

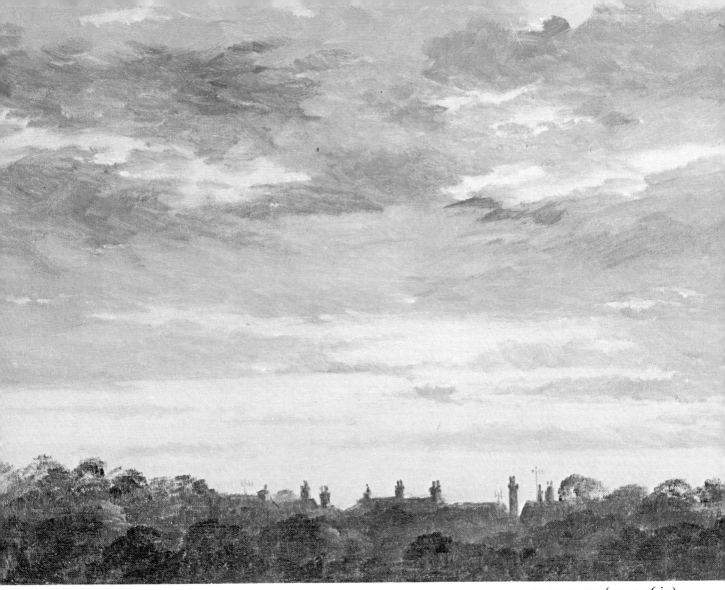

Finished stage 30 × 41 cm (12 × 16 in)

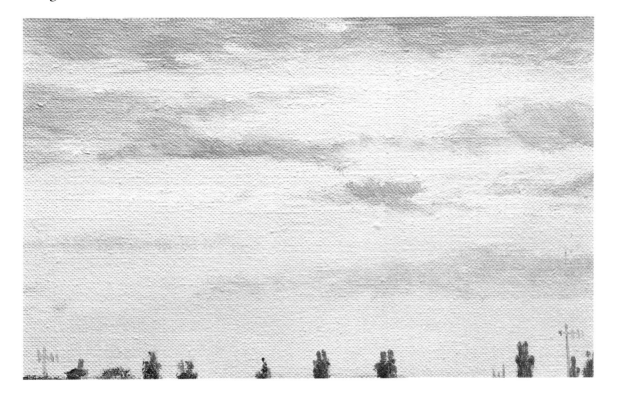

EXERCISE SEVEN
SNOW
IN ACRYLIC COLOUR

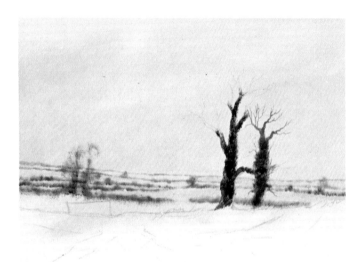

First stage

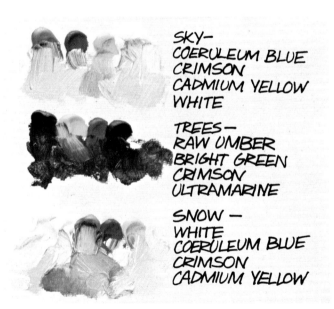

Second stage

SKY –
COERULEUM BLUE
CRIMSON
CADMIUM YELLOW
WHITE

TREES –
RAW UMBER
BRIGHT GREEN
CRIMSON
ULTRAMARINE

SNOW –
WHITE
COERULEUM BLUE
CRIMSON
CADMIUM YELLOW

This snow scene was painted from memory on an acrylic-primed canvas. It is late afternoon when the sun is low and casts a glow over the snow.

First stage Draw the main features with your HB pencil. Use your size No. 12 nylon brush and a mix of Coeruleum Blue, Crimson and White. Start at the top of the canvas and work down, adding more Crimson and Cadmium Yellow to the colours. Go well over the drawing of the horizon and down to the foreground tree. Using the same colours but hardly any White and your size No. 2 nylon brush, paint the distant trees and hedges. Then, using the same brush and plenty of White with your mix, paint the first snow-covered fields.

Second stage In the same way, paint the hedges and fields of snow up to the two middle-distant trees. Now use your size No. 4 nylon brush to paint the two trees in the middle-distance. Use a dry brush technique and don't put in any detail. With the same brush paint the hedge to the left and right of the trees, still using the dry brush technique. The colours to use are Ultramarine, Crimson and Raw Umber. For the two foreground elm trees I used Standard Formula to get texture on the tree trunks. Use your size No. 4 nylon brush and paint the right-hand tree first, up to the small branches, with a mix of Raw Umber, Bright Green, Crimson and a little touch of White. Then paint the small branches at the top with your size No. 6 sable brush, using Cadmium Yellow, Crimson, Raw Umber and White. *Paint the branches in the direction in which they are growing.* Now paint the left-hand tree, again using your size No. 4 nylon brush and the same colours as for the right-hand one, and Standard Formula. When the branches are too thin for the size No. 4 nylon brush use your size No. 6 sable brush.

Finished stage Continue with the smaller branches of the left-hand tree. Use more water with your paint – the paint will flow better – and add a little Ultramarine to your colour mix. Change to your size No. 6 nylon brush and, using the dry brush technique and the same 'tree' colours, drag the brush down over the small branches you have painted (left-hand tree only) and paint in the 'feathery' branches (see the illustration opposite). Now, with your size No. 4 nylon brush, paint the field in front of the two middle-distant trees, and over the drawing of the gate (which I left out – I thought the picture was very happy without it). The colour for all the snow is made up of White, Coeruleum Blue, Crimson and Cadmium Yellow.

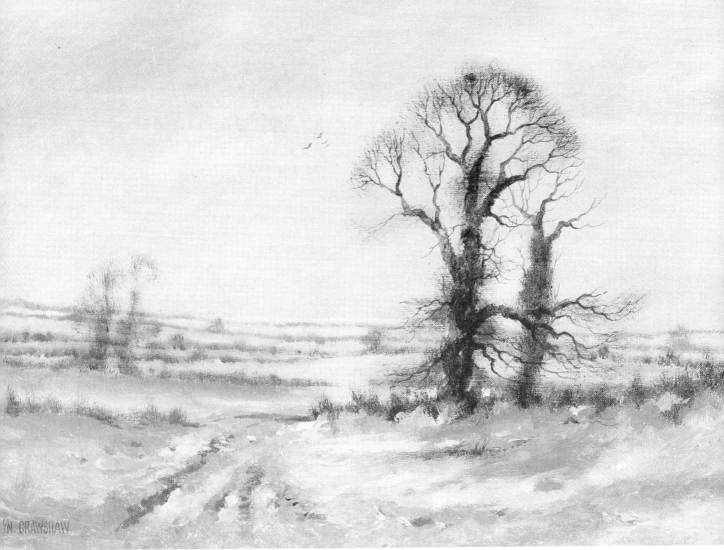

Finished stage

30 × 41 cm (12 × 16 in)

Paint the hedge on both sides of the path, using your size No. 4 nylon brush in upward strokes and a mix of Cadmium Yellow, Crimson, Raw Umber and Bright Green.

The foreground snow is next. It is difficult to explain each brush stroke, but I will explain roughly how I have painted the snow – do it the same way, but don't try to copy. Start with your size No. 4 nylon brush and paint the earth that can be seen on the path and field with Cadmium Yellow and Crimson. Then work in the snow using snow colours. I added Texture Paste to the paint to give texture

to the snow. Work in a low key as I explained in the section on ground and snow Then put in your highlights and darks when your foreground is dry. Paint your path in perspective, letting your brush strokes follow the direction of the path. Finally, add any more detail you feel is necessary to the trees with your size No. 1 sable brush and add highlights to the tree trunk and branches, using Bright Green, Cadmium Yellow, Crimson and White. Put in the birds' nests and birds with your size No. 6 sable brush and a mix of Burnt Umber and Ultramarine.

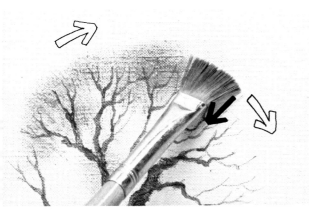

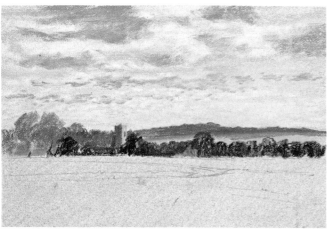

First stage

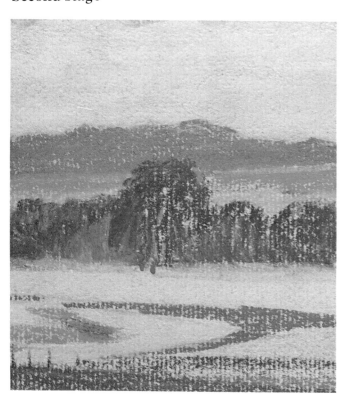

Second stage

EXERCISE EIGHT
WATER MEADOWS
IN PASTEL COLOUR

I worked this pastel painting on an Ingres paper from a sketch of Send Church that I drew on location, but in the last stage I changed the foreground field to give the effect of a slight hill. This gave the picture more strength, especially with the heavy shadow on the field.

First stage Draw the main features with your HB pencil. Then, using Cobalt Blue Tint 2, paint the blue sky areas with the broad edge of the pastel. About two-thirds of the way down, change to Cobalt Blue Tint 0. Work back into the first colour and then carry on down to the horizon. Now, with the broad edge of Raw Umber Tint 1, paint the light clouds, starting at the top and working down. Work them freely over the blue sky to the horizon. Work over the blue sky with Cool Grey Tint 4 and put in the dark clouds. For the distant trees use Green Grey Tint 4, then use Olive Green Tint 0 for the field underneath, working back into the trees slightly. Now paint the field underneath, using Sap Green Tint 3.

Second stage Now, using Purple Grey Tint 4, paint the trees behind and to the left of the church. Then, with Sap Green Tint 8, work the two trees at the left of the picture, over the background trees you have just done. For the shadow side of the church, first paint with Cool Grey Tint 6 and then paint over this with Burnt Umber Tint 4. Use Burnt Sienna Tint 2 for the sunlit side. Next paint the dark trees to the left and right of the church. Use Green Grey Tint 6 and, in places, add Olive Green Tint 4 over the top to give a tonal change. Start using Cobalt Blue Tint 2 just before the large tree to the right of the centre, then continue over this layer of pastel to finish the line of trees. Finally, with Cadmium Red Tint 4, paint the two roof tops and smudge them with your finger.

Finished stage Using Yellow Ochre Tint 2, paint the sunlit field and work it into the bottom of the row of dark trees. Now paint the water with Cobalt Blue Tint 0, and give the shadow 'line' of the bank its shape by drawing with the end of a Cool Grey Tint 6 pastel. For the field on the left-hand bank use Sap Green Tint 1, and for the bank itself use Olive Green Tint 4. With broad, free strokes and Sap Green Tint 8, paint the foreground field, and over this add Grey Green Tint 6 to give depth to the shadow area. Don't be afraid to use pressure on the pastels when working on the foreground. Draw the fence with Grey Green Tint 6. Add highlights or darks where you feel they are necessary.

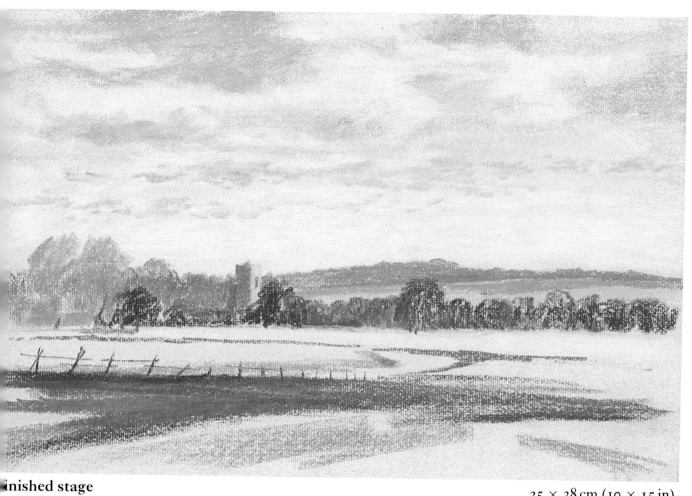

Finished stage

25 × 38 cm (10 × 15 in)

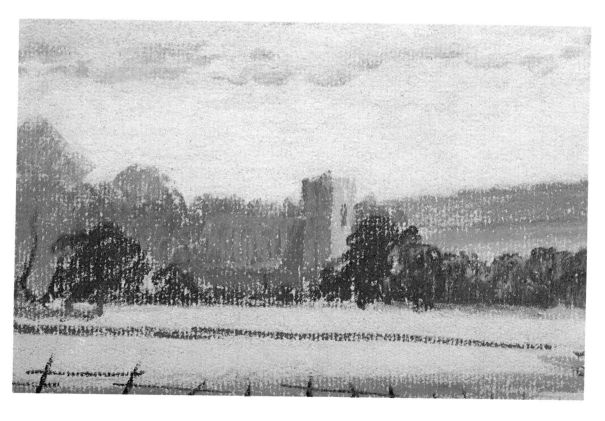

EXERCISE NINE
FARM BUILDINGS
IN WATERCOLOUR

First stage

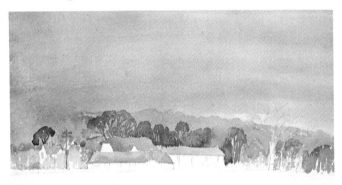

Second stage

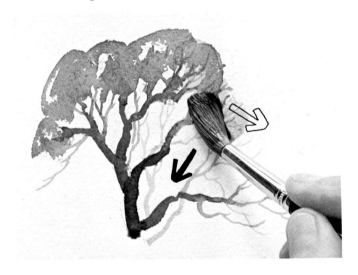

This landscape was painted from a pencil sketch which
did of a farm at Binswood in Hampshire. I did the sketch
(which was the same size as this watercolour) with no idea
of when, or even if, I would use it for a painting at home.
I suddenly had an urge to paint it in watercolour as an
exercise in this book, and I am very pleased with the result.

First stage I used GREENS RWS 140lb NOT SURFACE water
colour paper. Start by sponging the sky area with water
down and into the area of the trees, but not over the roofs.
While the paper is still very damp use your size No. 1
sable brush and paint the sky with Payne's Grey and a
touch of Crimson Alizarin. Halfway down the sky add
Yellow Ochre to your wash and work down to the right of
the barn.

Second stage While the sky is still damp, using the same
colours and your size No. 6 sable brush, paint the trees on
the hill in the background (notice how this runs into the sky
at the left of the buildings – this is a controlled accident).
When this is nearly dry, using the same colours but darker,
paint the dark trees behind the buildings. 'Draw' these with
the brush to give the individual shapes. Behind the large
tree on the right drag the brush (using dry brush technique)
down behind the tree which gives an effect of watery sun-
light on middle-distant trees. Now paint the trees to the
left of the buildings and behind the telegraph pole. Add
more water and more Yellow Ochre. Still using your size
No. 6 sable brush, paint in the roof of the extreme left
house and the window with a wash of Crimson Alizarin
and Cadmium Yellow Pale. With the same brush, using
your tree colours, put in the telegraph pole. Now paint the
roof of the barn behind the bungalow, using a strong mix
of Crimson Alizarin and Cadmium Yellow Pale. Add a
little of the tree colours to this mix for the bungalow roof
to give a weathered look. For the grey-roofed barn mix
Ultramarine, Crimson Alizarin and a touch of Yellow
Ochre. While you are working on these two stages, you will
find that you have areas of colour left on your palette. Don't
wash them off – use them throughout your painting.

Finished stage With your size No. 6 sable brush, work
the end of the barn, using a very watery wash of Raw
Umber and Payne's Grey. Leave white paper showing
between each brush stroke to represent highlights on the
timber edges. For the inside of the grey-roofed barn mix
Payne's Grey, Crimson Alizarin and Yellow Ochre. Leave
white paper to represent the support posts and add more

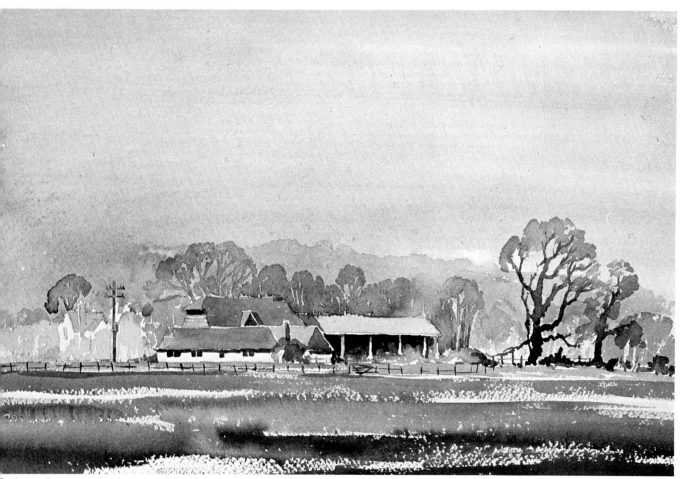

inished stage

27 × 41 cm (10½ × 16 in)

ellow Ochre as you come to the bottom. Work this colour
t and to the right of the barn. Put another wash over the
ofs, using the original roof colours, but don't do this on
e sunlit areas. Paint the large tree next, using your size
o. 6 sable brush and a wash of Payne's Grey and Burnt
mber. Work the brush up the tree and paint the main
anches. Also paint the tree to the right of this. Put in the
ace under the tree with the same colour. Then, while the
o trees are still wet, and using the same colours, put in
e feathery branches, letting the wet wash run into the
t branches. Using the same colours, but darker, paint
derneath the grey-roofed barn again to make it darker.
not paint down to the bottom this time, and also paint
lfway down the white support posts. Use a mix of
ench Ultramarine, Crimson Alizarin and a touch of
dmium Yellow Pale to paint the window and shadows
the bungalow and barn. Now comes the green field
oss the picture and in front of the buildings. Use your
e No. 6 sable brush and a mix of Hooker's Green No. 1,
imson Alizarin and Yellow Ochre. With your size No. 10
le brush and a wash of Cadmium Yellow Pale, Crimson
zarin, Burnt Umber and a touch of Payne's Grey, paint
ploughed field in the foreground. Use plenty of paint
l be very free, leaving white paper showing through to
e life. Nearer to the foreground add a touch of Hooker's
een No. 1 with your size No. 6 sable brush. Put in the
ce and any accents you feel are necessary.

DO'S AND DON'TS

DO NOT USE ACRYLIC COLOUR OVER OIL COLOUR

DO NOT PUT IN TOO MUCH DETAIL WHILE YOU ARE LEARNING

PAINT PLANTS, SHRUBS, TREES, ETC., IN THE DIRECTION OF GROWTH

REMEMBER THAT WATER MUST APPEAR HORIZONTAL

REMEMBER THAT THE SKY CONVEYS THE MOOD OF THE LANDSCAPE

BUY THE BEST MATERIALS THAT YOU CAN AFFORD

VARY THE AMOUNTS OF COLOURS USED IN A MIXTURE

DO NOT BE AFRAID TO USE PHOTOGRAPHS — AS AN AID

ALWAYS PUT SOMETHING IN YOUR PAINTING TO DENOTE SCALE

REMEMBER THAT OBSERVATION IS THE KEY TO GOOD PAINTING

REMEMBER TO CLOSE ALL GATES AFTER YOU IN THE COUNTRYSIDE

ENJOY YOUR PAINTING, REMEMBER THAT IT'S FUN

AND TAKE IT EASY — PRACTISE, PRACTISE, PRACTISE AND DON'T RUN BEFORE YOU CAN WALK!!